Surface Decoration

Surface Decoration

Kevin Millward

Bloomsbury Academic
An imprint of Bloomsbury Publishing Plc

B L O O M S B U R Y
LONDON · OXFORD · NEW YORK · NEW DELHI · SYDNEY

Bloomsbury Academic
An imprint of Bloomsbury Publishing Plc

50 Bedford Square
London
WC1B 3DP
UK

1385 Broadway
New York
NY 10018
USA

www.bloomsbury.com

BLOOMSBURY and the Diana logo are trademarks of Bloomsbury Publishing Plc

First published 2017

British Library Cataloguing-in-Publication Data
A catalogue record for this book is available from the British Library.

ISBN: PB: 978-1-4081-7378-7
 ePDF: 978-1-3500-0651-5

Library of Congress Cataloging-in-Publication Data
Names: Millward, Kevin, author.
Title: Surface decoration / Kevin Millward.
Description: New York : Bloomsbury Academic, 2017. | Series: The new ceramics | Includes index.
Identifiers: LCCN 2016009043 (print) | LCCN 2016017646 (ebook) | ISBN 9781408173787 (paperback) | ISBN 9781350006515 (Epdf) | ISBN 9781350006508 (Epub)
Subjects: LCSH: Pottery—Technique. | Decoration and ornament. | BISAC: DESIGN / Textile & Costume.
Classification: LCC NK4225 .M55 2017 (print) | LCC NK4225 (ebook) | DDC —dc23 LC record available at https://lccn.loc.gov/2016009043

Series: The New Ceramics

Cover design by Terry Woodley

Typeset by Lachina
Printed and bound in China

Contents

Introduction

My interest in ceramics was sparked as a small boy watching pots unearthed on archaeological digs with my mother. Many cultures that have worked with clay developed their own distinct styles and decorating techniques. Clays, colours and firing processes were often restricted by locally available materials and resources. These items, when discovered by archaeologists many centuries later, are often used to form an idea as to the state of development of that culture.

Over the centuries man's ingenuity and creativity, combined with the benefit of advances in technology, have been able to develop a vast range of decorative techniques, processes, glazes, slips and colours—never more so than at the start of the Industrial Revolution. This bringing together and processing of raw materials from all over the world enabled a standardisation and consistency never before seen, resulting in a vast array of clay body types, colours and glazes.

The development and advances in the control of the firing practises consequently led to an explosion of decorative techniques and some distinct regional styles and methods. One example of this was Staffordshire and the development of bone china, using lead glazes and decorated with fine hand painting using a vast array of coloured enamels and embellished with gold.

Many of the techniques have filtered down from the industry to become everyday processes for the studio potter. More recent advances have led to a vast range of colours that are stable through a wide range of temperatures and techniques expanding the range of surface decoration possibilities.

Many potters maybe do not see themselves as decorators in a traditional sense and maybe prefer a more minimalist approach to shape, form and texture; however, there is still the quality of the surface to consider.

With this book I hope to introduce you to a range of decorative techniques and glazing processes that will guide you to the appropriate choice of surface treatment for your pots. I have written this book mainly from personal experience in that I have either used the techniques myself or have worked with other potters or students in developing the use of these processes. Any potter will tell you it is one thing to know a process from an academic perspective or to read it in a book and think it will work first time. It is yet another to actually put the process into practise. It is the subtle nuances of a technique and all the associated problems that make it work for you.

I hope this book will give you the information necessary to explore the range of techniques and processes available today and maybe come up with something new. I also hope that it will give you the opportunity to put some of these techniques and processes into practise.

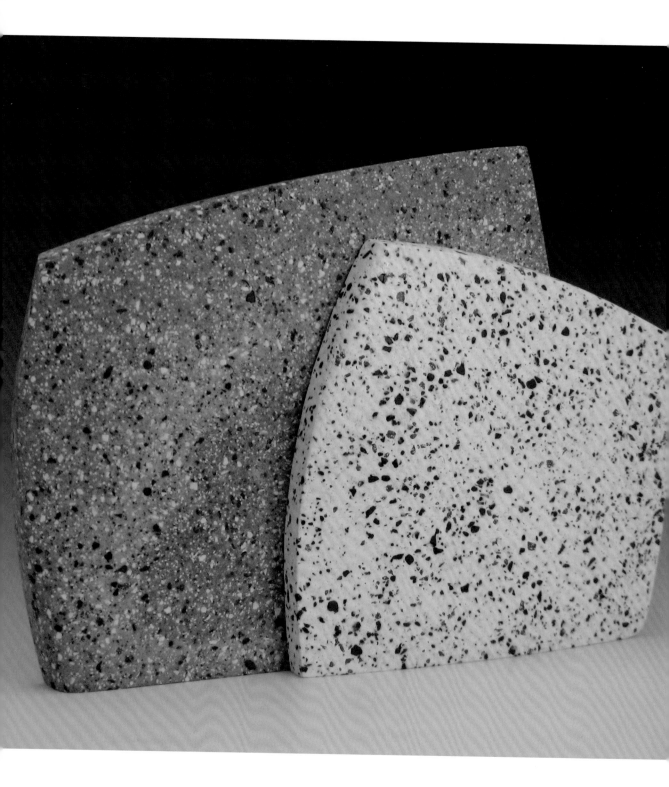

Raw Techniques

Colour in clay

You can add raw oxides or body stains to achieve the effect of coloured clay for inlaying or hand building shapes and forms. The clay body you choose can be seriously affected by the addition of oxides and stains. They may increase but more likely decrease the maturing point, or recommended firing temperature, by as much as 50°C (122°F), thereby dramatically increasing the shrinkage rate of that clay. So if you are combining colours, you must consider these effects, as they can cause severe distortion, splitting, cracking, and in some circumstances, a complete meltdown. You can try to balance out these effects by adding more refractory materials, such as china clay, but as with all alterations to any standard clay bodies, you must test thoroughly. You can test the shrinkage and flux point by making sample tiles of a set length of, say, 10 cm at the wet stage and then fire and remeasure to calculate shrinkage and colour response. Then you can make adjustments as necessary. There is no substitute for testing.

If you are not glazing the surface, you might need to increase the amount of stain used to obtain the depth of colour required. The colour of the base clay will affect the final colour too, so although it may seem strange, the best black clay bodies come from a white clay base. I have made black clays in the past from a terracotta base but have always found them to have a slight hint of chocolate about them. It is also worth checking that the firing range of the stain is compatible with the firing temperature of the clay body. If you are intermixing stains, again you should check their compatibility before using. If in doubt, consult your supplier. Follow normal safety instructions when using oxides and calcined colours, as some are considered carcinogenic. Therefore, don't eat or drink when you are working with them. If you are tempted to use underglaze colour to do the same job because the colour is more desirable (there can be a wider range of colours available in underglaze than body stain), be wary as they can, in some rare circumstances, have a deflocculating effect on the clay body, due to the use of sodium silicate in processing. Without extensive testing, it is best to stick to body stains.

Agate

Some people confuse the agate technique with marbling (see page 47). Agate is made up of layers of coloured clays gently kneaded together to create a marbled pattern before you commence throwing or hand-building techniques, whereas marbling is a

LEFT: **Fused aggregates**
Photo: by David Binns.

surface decoration using slips on the surface, as described in Chapter 5. As previously discussed (see page 44), when you are mixing more than one clay body together, they must be compatible in both shrinkage rate and firing range so as to provide an even porosity and shrinkage rate when fired to the maturing temp of the body with or without a glaze. When using traditional hand-building techniques, you can control the pattern to a greater degree; this process is similar to the processes used in millefiori. As with all of these techniques, you still need to scrape the surface clean or turn the surface to reveal the pattern on a thrown form.

If you do not intend to glaze the pot but instead wet and dry the surface after a soft biscuit firing, say to 950°C (1742°F), when you are happy with the surface, you can fire the pot to its vitrification point when it is possible to further improve the surface with diamond abrasive pads. Burnishing is not always an option at the clay stage, as this can blur the colours. The amount of stain you need to add for this unglazed finish can be much greater than when coating with glaze, so you must test to establish the correct amount of stain to be added for the temperature you intend to fire to. If in doubt, contact the supplier for advice; the supplier should supply you with the manufacturer's recommended additions. If you are going to glaze over the surface with a clear glaze, do not panic if the colours appear pale and almost insipid at the biscuit stage. They will be brought out by the glaze when fired.

BELOW: Agate bowl
Photo: by Kevin Millward.

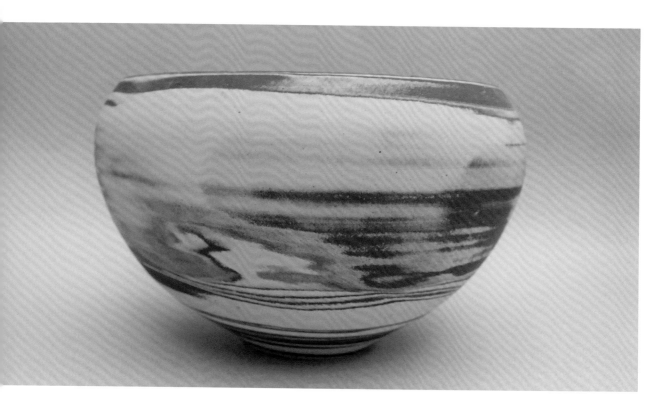

Millefiori (also known as Nerikomi)

Millefiori is a term used mainly in glass making. It means a thousand flowers and refers to the multicoloured glass rods used in the production of glass objects such as paper weights. Its use in ceramics is similar in that you prepare a block of clay made up of a simple or complex pattern assembled from coloured clays that fire and shrink at the same rate. You can then cut sections off the end of this block of clay and use them to construct the walls of the form. The sections of clay are usually placed in a mould made of plaster or soft biscuit-fired clay; the mould supports the clay during construction because the form has no integral strength of its own. Ensure that the parts are well joined. If they are not, the whole thing will unravel or at best be full of cracks. The slip used to join the parts can itself become part of the pattern. Remember that the colouring of the clay and slip to join them must obey the same rules as in agate (see page 10), as compatibility in both firing range and shrinkage is essential.

The assembly of the section can appear a little on the rustic side at first, but the true nature and complexity of the pattern you have created can be revealed only after both surfaces are scraped back. Take great care at this stage because the form can be extremely fragile, especially if you want to achieve a very thin-walled section. If you require a fine finish, I recommend that you sand down the surface after soft biscuit firing, thus allowing a finer section than can be achieved at the clay stage without the danger of breakage. If you have used black carborundum wet and dry paper, make sure you wash off all traces as it can create problems in later firings.

Inlay

When inlaying one clay into another, as with any process where clays of different types or colours are used, you must ensure compatibility. The methods of inlaying can be as simple as cutting a single line into the surface of a leather-hard pot and then infilling with coloured slip, allowing to dry and then scraping back. The Staffordshire potters in the eighteenth century produced a type of ware called scratch blue on which they scratched a line into the dry clay and would then rub cobalt oxide into the marks after biscuit firing to reveal the simple pattern when glazed.

One method I particularly favour is to throw a basic form such as a simple bowl with overly thick walls and then cut out small sections, preferably without going all the way through. Using the clay you have removed, mix this with a small amount of copper carbonate or any other colourant you wish. Now put the clay back into the same hole it was removed from, making sure you have not trapped any air. Then continue throwing your pot. After biscuit firing, apply a simple Chun glaze over the top, and then fire to 1280°C (2340°F) under either oxidisation or reduction atmosphere. Encaustic tile makers have used this method to great effect for centuries in the production of flooring, particularly Minton Hollins of Stoke-on-Trent in the nineteenth century.

ABOVE: Millefiori
Photo: by Dorothy Fiebleman.

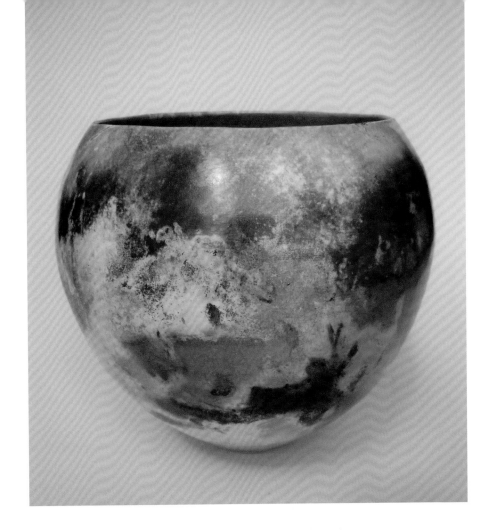

Terrasigillata

The form of applying slip to the surface of a pot, known as terrasigillata, is derived from a Roman technique. It differs from the standard slipping process in that the clay slip is traditionally levigated so as to use only the finest particles of clay, taken from the host body. This ensures a perfect fit. You can build a simple system for taking off these finer particles, but you will be left with only a small amount of the very finest slip. When applied to the host pot and burnished, the slip can create an almost impervious surface. This technique was used as a way of making the pot watertight before the development of glazes.

Most potters using this technique use a standard ball clay because it provides a smooth clay to start with. Many potters today add a deflocculant such as sodium silicate or the laundry powder Calgon to create a false fluidity to speed up the settling of the heavier particles. This technique increases fluidity without the addition of more water, but some potters prefer to use sodium hexametaphosphate (see the appendix for a slip recipe). At the end of the day, how you achieve the desired effect is what works best for you, so rigorous testing is usually necessary.

If you intend to add stains to the slip, it is worth noting that after mixing, you will probably have to ball mill the slip to ensure the stain does not create a grainy surface. Many potters prefer to use chlorides of metallic oxides (such as cobalt chloride for blue) as they blend in to the slip without the necessity to ball mill them. (Please note that chlorides are toxic and must be handled with care.) You then need to pass the slip through a fine sieve such as 200s mesh. Don't force the slip through on the final pass, and always sieve again before you start decorating. Apply your slip, building up the slip layers by dipping or brushing. Or you can spray if you have the necessary equipment. Providing the surface is dry enough, you can burnish the surface using a wide range of tools from the back of a spoon to a favourite stone. If you use anything that is not stainless steel on white or light firing clays and slips, it can stain the surface with rust marks that do not always show until after you have fired the pot.

Aggregates

An aggregate is created by adding a pre-fired material to a clay body, so simply adding grog, sand, chamotte, or molochite would qualify. Potters have used aggregates for centuries to impart strength and workability and cut down on shrinkage, as well as to define surface texture. But there is a growing movement to expand on this technique and add a whole range of suitable ceramic materials into clay to impart colour and texture to a greater extent than ever before. Most clay bodies that have large quantities of pre-fired material added (possibly over 50 per cent of the total) may require some form of mould, usually made of a mixture of plaster of Paris and silica, to hold the raw materials together during firing. It is in the kiln that the aggregates fuse together to produce a consolidated form.

Some of these techniques require much work after firing and are more akin to glass working than pottery, as they involve cutting, grinding, and using wet and dry carborundum paper. As a compensation for the high levels of elbow grease required after firing, the end results can be quite stunning and sculptural.

Fused aggregates,
cut and polished
Photo: by David Binns.

2

Texture

Sprigging

When most people think of sprigging, the classical pottery of Wedgwood comes to mind; the characteristic white figures on a coloured background are iconic. Moulds made from plaster are commonly used, and found objects can provide a wide range of textures and patterns. The moulds used in industry are pitchers; i.e. biscuit-fired clay, as they last longer and do not damage easily. A small amount of vegetable oil can be used as a release agent, but you should not overdo this as it may prevent the sprig adhering to your pot. A clay of contrasting colour can be applied over a base form, but again you must be sure of the compatibility of the two bodies you are to bring together.

Use a small amount of water to stick the two parts together at the leather-hard stage. You can use slip, but don't overdo it as it can get very messy, particularly if you are using contrasting colours. If the form is too dry, the chances of your sprig falling off are greatly increased. The standard practise is to force the clay into the mould so as to capture all the detail and then scrape back so clay is level with the back of the mould. This can be a problem with plaster moulds as they are soft and you can easily cut into them.

To remove from the mould, use a palette knife on the back of the sprig to create suction, allowing you to gently remove the sprig from the mould and apply directly to the pot. Some potters use a small ball of clay to do the same thing, but it can stick to the back of the sprig.

Relief

Relief can cover a wide range of processes, but most people think of it as any raised or incised surface on a pot that was not achieved by sprigging. This could include the carving into, modelling onto the surface of, or application of heavy or deflocculated slips that retain their raised surface when dry. The application of clay motifs such as swags and trellising on large garden pots is a prime example. As with any process in which you are applying one clay or slip over another, compatibility of the materials used and application at the right time are essential.

LEFT: Polished bone china
Photo: by Angela Verdon.

LEFT: Thrown and sprigged
terracotta jugs
Photo: by Philip Wood.

There is a great history of relief decorating in ceramics—from South American potters to Palissy ware decorated with animals and reptiles and its imitators. There was a great vogue for lavish and complex decoration by the Victorian potters, such as those producing majolica wares. Minton is a fine example.

Casting methods

The great thing about slip casting is that it will faithfully reproduce any mark on the surface of the plaster mould. However, you must understand that different clays respond differently to deflocculation: the more plastic the clay, the more difficult it is. For example, terracotta is complex, but bone china is much easier. Casting slips requires a delicate balance between pint weight fluidity and thixotropy. It may be best to buy ready-mixed casting slip if you are a beginner.

You can make plaster moulds or buy a standard shape with marks or textures cut into them or take them from found objects as long as there are no major undercuts preventing removal. The application of materials, whether organic or not, to the surface of the mould before the mould is assembled can create some complex surfaces. It is also possible to cast layers of coloured slips, one over the other, and then cut back through the layers to reveal the other colours.

To use this technique, cast a form in bone china, then in the clay and soft biscuit stage. Next, cut, grind, and polish the surface before vitrification; and finally, polish the surface again.

RIGHT: Vase with sprigged
decoration
Photo: by Kate Malone.

BELOW: Hand-thrown stoneware
dish with sprig decoration
Photo: by A & J Young.

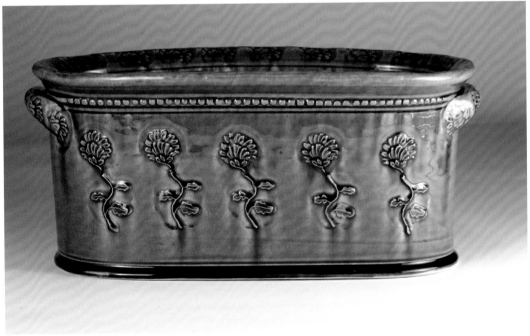

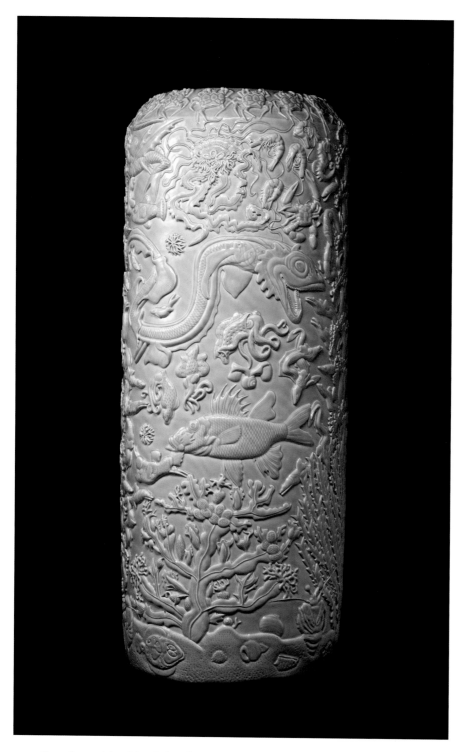

ABOVE: Carved porcelain with celadon glaze
Photo: by Roger Law.

Materials added and burnt out

Another area of ceramics has grown and developed over the years to include many new materials in the mix.

Paper clay is quite common today, as you can buy a wide range of clays from your supplier with the paper already added for you—from earthenware to porcelain, Parian, and bone china. On my wall I have a large plaque made from bone china paper clay that is as thin as a sheet of paper. The advantage of purchasing these clays from suppliers is that there are no problems with the dreaded black mould that appeared when potters made their own. The addition of organic materials from sawdust to rice and many types of breakfast cereal creates interest. My philosophy is that if it can burn out without creating too many noxious fumes, give it a go.

Some additions play a more important role in imparting strength to the green clay while under construction. A common one is hollow fibre used to stuff sleeping bags, as it will bind clay together, thus preventing splitting and excessive cracking on very thin edges. This technique is good whether you are throwing or hand building, and it burns away at normal biscuit temperatures. Carbon fibre does the same thing but remains after firing. Some materials added to clay give false plasticity, such as gum arabic in bone china flower maker's clay. These products enable complex and intricate moulding of flowers and even the weaving of wicker-style baskets in clay. An added bonus is that they act as a glue to hold the item together in the green state until it is fired.

Possibly one of the strangest things I have seen is adding silicone sealant to clay and then extruding a piece of clay as thin as a shoelace. This technique enables the potter to knit with this flexible material, which again just fires away.

RIGHT: Slip cast bone china, vitrified and polished
Photo: by Angela Verdon.

LEFT: Slaked down casts
Photo: by Neil Brownsword.

LEFT: Testing casting slip
Photo: by E J Payne.

ABOVE: Cast-coloured bone china, cut and polished
Photo: by Sasha Wardell, Mark Lawrence.

3

Stamps

Stamping

Stamps have a long history of use in pottery. The advantage of stamping is that stamps can be used on any ceramic surface, from wet clay to a glost surface, and they can be made from any material. You can purchase stamps from ceramic suppliers in a wide range of designs, from complex patterns to simple letter stamps, or you can make your own using a variety of materials such as wood, clay, plastic, rubber, or lino. Alternatively, you can have them custom made; for example, you might want something as simple as a back stamp with your name on it. As you become more adventurous, you can use custom-made stamps and tools for impressing.

I have a penchant for found objects because these shapes can provide some unexpected benefits. Using rusting metal objects impressed into porcelain can give both texture as well as colour; the staining comes from the iron oxide, commonly known as rust. I find the combination of impressing and a fluid-coloured transparent glaze complementary. Another popular surface treatment is to rub in colour or raw oxide to emphasize a texture or pattern in the surface.

One form of stamping is the roulette wheel that is used to stamp a pattern into a pot as it rotates on the wheel during throwing or turning. These tools are mostly made from brass but can be made of plaster or plastic. These are, again, available from your supplier.

Lettering

Lettering can be achieved through many approaches such as free-hand painting, slip-trailing, printing, and stamping. A wide range of stamps is available from your supplier or the internet, which means that the range of options open to you is as wide as the typefaces available. It is really a case of choosing the lettering style, technique and process that best suits your method of decoration.

A friend of mine spent most of his working life in the industry. Instead of painting lettering in gold directly on the inside of a pot, he would draw the letters out on thermoflat paper in the desired typeface, overlay this with screen printing gold and then apply a cover coat. This technique works for many colours and also prevents you from making simple errors such as spelling mistakes directly on the pot. Always get someone to check your spelling, as once it's on the pot, it may be too late to correct—as I have learned through experience.

LEFT: Embossed dish
Photo: by Linda Chew.

ABOVE: Hand-built porcelain dish; embossed surface highlighted with cobalt
Photo: by Linda Chew.

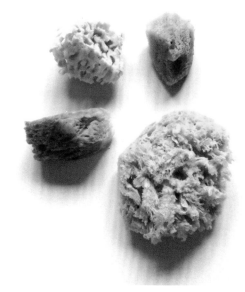

ABOVE: Assortment of sponges
Photo: by Kevin Millward.

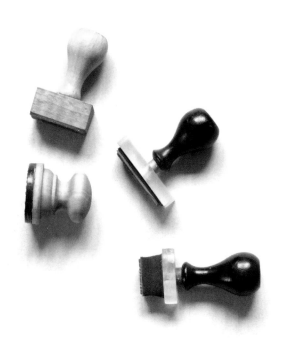

ABOVE: Assortment of stamps
Photo: by Kevin Millward.

ABOVE: Assortment of stamps and stencils
Photo: by Kevin Millward.

RIGHT: Thrown porcelain,
letter stamped inside rim
Photo: by Gemma Wightman.

Sponging

The type of sponge you use determines the finish of the print. A very open sponge gives a more blotchy effect, and a tighter grain gives a smooth finish. Sponges are normally cut with hot wire or a soldering iron. Some sponges can give off toxic fumes, so if you don't know what type of sponge you have, make sure you cut it in a well-ventilated area. I recently learned a technique that does not use heat. This technique involves soaking the sponge in water and then placing it in the freezer. When it is frozen solid, you can use a craft knife to cut out the shape you require and then leave it to thaw out before use.

Emma Bridgewater is well known for using stamping with cut sponges onto biscuit ware in the same tradition as the Victorian potters. Alternatively, sponging can be as simple as using natural sponges and colour to produce a wide range of simple patterns over the pot with underglaze colour and a transparent glaze on top.

A wide range of media can be used to carry your colour, whether it is underglaze colour or raw oxide. Water is a common medium, but it can leave the colour very dusty on the surface. When dry, this can cause problems such as crawling when it comes to glaze application. The traditional method was to use an oil-based medium like fat oil and turpentine, but this must be fired out before glazing, a process known as hardening on. This technique can create its own problems, as variations in the porosity of the biscuit surface may occur, affecting the ability to take up glaze. As a result, this method is normally reserved for application to high-fired biscuit ware. Again, the glaze would have to be flocculated to compensate for the lack of porosity in the biscuit ware.

LEFT: Thrown stoneware box with sponged decoration
Photo: by John Calver.

LEFT: Hand-cut sponge
Photo: by Emma Bridgewater.

Many colours today come ready prepared in a water-based medium and can be glazed over with no problems. The reason is that the medium fires away through the glaze layer without detriment to the surface. The colour fluxes well before the glaze, so it is never dusty under the surface of the glaze, thus preventing any possibility of crawling. This process can also be used on an unfired glaze surface similar to maiolica. Application to a glossed surface is also possible, providing you use a suitable medium with colours that are in powder form. I have found glycerine very good for this use, as it is cheap, readily available, and nontoxic. It also dries out to a hard durable surface that is not prone to damage when placed in the kiln. I also have used the same process to directly apply potato prints onto glazed white tiles.

4

Resist and Masking

Hot wax

Potters use two main types of wax resist. The first is hot wax, or melted paraffin wax. Some potters are nervous about hot wax, as it can cause a fire. Therefore, it is important that you never leave it unattended. If you have to leave the room for any length of time, remove it from the heat source. Hot wax has advantages when used in conjunction with glazing, especially where you dip one glaze over another to prevent an area receiving the second glaze. It is excellent for splashing wax and glaze in a decorative way because it sets on contact, enabling the build-up of multiple layers. It also is very good for waxing out galleries and foot rings. Unfortunately, if you make a mistake, you can remove it only by re-biscuit firing.

Brush wax

Many potters use the second type of wax resist, brush wax emulsion, to resist an area they don't want to receive glaze or colour. Again, if you make a mistake, it can be removed only by refiring the pot. I have found that the wax emulsion works better for me when diluted with a small amount of water, as it is less gloopy. You have to be careful not to overdo it though. I have used this type of wax for sponge printing onto a glazed surface. It does not dry too fast on the sponge, and it can be washed out with water, as long as it has not set. If you want to use it for waxing out galleries, lid fittings, or the places where two ceramic surfaces come together, I recommend adding a small amount of calcined alumina, as this helps prevent lids sticking by leaving a small amount of alumina behind when the wax has burnt away.

Rubber solution

Rubber solution resist is a method that you may not always think of, but it has the advantage that you can use it and remove it without detriment to the biscuit surface. It can be used for multiple layers of glaze or colour application. But be warned, though; it can make a mess of your brushes, so don't use your expensive or favourite ones.

LEFT: Stencils and underglaze colours
Photo: by Jacqui Atkin.

Many years ago when I was making terracotta domestic ware, I used rubber solution to resist glaze in the galleries of storage jars and the like. Sometimes when I was using brush wax, small beads of glaze would stick to the wax and were very difficult to remove without damaging the glaze, causing the lids to stick if not fully removed. By using rubber solution, I could remove the film quickly and cleanly, along with any residue—so no stuck lids.

Paper stencils

Stencils have a long history of use in ceramics as a means of repeating a design. Stencils can be made from paper card or, traditionally, thin sheets of lead with small holes pierced through, tracing the design. Graphite dust or chalk can be dusted through, commonly referred to as pouncing. Stencils made from paper or card are probably the most common type when you're making your own. It is now possible to use software to manipulate an image that can be cut out by mechanical means, a pair of scissors or a craft knife, but for the low-tech, traditional drawing onto newspaper and then cutting out by hand is probably the norm.

BELOW: Assortment of craft knives
Photo: by Kevin Millward.

BELOW: Slab built with underglaze colour decoration
Photo: by Jacqui Atkin.

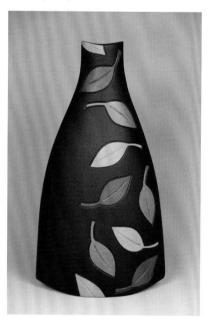

ABOVE: Thrown earthenware dish with paper
resist and slip-trailing
Photo: by Mark Dally.

RIGHT: Slip cast earthenware jug and thrown
butter dish with paper resist and brushed
slip
Photo: by Jane Cox.

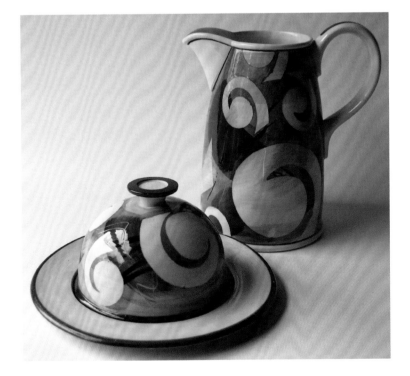

You can build up multiple layers with this stencil technique, again using slips or colours. When it is dry, you can remove the stencil, being careful not to disturb the slipped areas. I find a craft knife or scalpel best for this process. Sometimes the slip or colour can sneak under the stencil, so if this does happen, you can remove it in most cases by careful, gentle scraping when dry. You can apply more stencils if you wish and repeat the process, but be careful not to overwet the pot and cause the pot to slake, crack, or even collapse.

Masking/adhesive tape

Masking tape can be used to cover a surface before decoration, a process often used by potters using the naked raku technique. It has the advantage of being self-adhesive, comes in a range of widths, and is easy to cut with either craft knife or scissors. Other types of tape such as adhesive tape or electrical tape can be used, and a range of tapes used in the car spraying and detailing industry also can be adapted. They can be used very successfully on glost-fired surfaces because they peel away easily. I recommend a trip to your local stationer. A range of peel-off vinyl sheets also is available; they can be hand cut or cut out by computer. Some local print shops may have the facilities to custom cut letters and shapes for you for a small charge. They simply peel from the backing and apply to the surface. Again, check the edges are stuck down well.

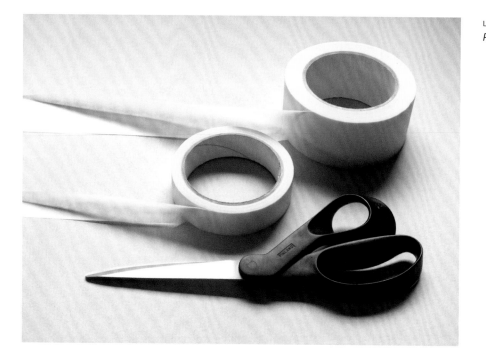

LEFT: Masking tapes
Photo: by Kevin Millward.

ABOVE: Slip cast stoneware
tile with resist masking,
lettering and gold
Photo: by Regina Heinz.

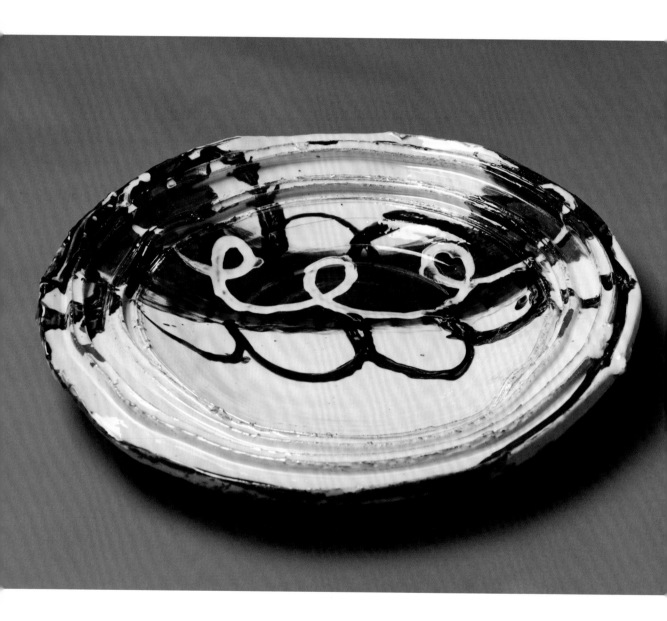

5

Slip

Slip-trailing

The potter's use of slip stems from a need for simple decoration and to create a whiter surface to decorate. By slaking down small quantities of clay to produce a liquid that could be poured or brushed onto the surface of another darker coloured clay, the potter could create the appearance of a white pot and produce coloured slips for decoration by adding raw oxides or stains.

Most cultures have used the slip trailer in many different forms. Early examples were based on using a horn or something similar and controlling the air flow into the horn. The addition of a quill to deliver a thin or thick line of slip enabled the potter to control the subtlety of the decoration. Some of the most famous examples were produced by the Toft family in Staffordshire in the seventeenth century and revived later by studio potters.

As with most ceramic techniques, it is essential that the right equipment and tools are used and that the materials have been correctly prepared before use. Many different types of slip trailers are available on the market, so it may take some time to find the one that best suits you. I suggest first developing your design on paper with simple line drawings, taking into account the limitation of the slip trailer before committing it to the pot. It is very difficult, if not impossible, to correct a mistake afterwards, as can be seen on some examples of Toft ware. It is a good idea to practise on a flat surface with your slip trailer to get a feel for this tool, as this will give you an idea of the flow rate of the slip from your chosen type of slip trailer. The sign of good slip-trailing is a fresh, fluid line and a degree of spontaneity that gives vitality to the work.

These elements are critical to how this technique is executed and the quality of the outcome, so control, repeatability and the ability to work out your starting and finishing point are essential. Making sure the trailer is kept full is important because if the slip runs out, you could have a splat of air and slip all over your work. I recommend controlling the fluidity of your slip by using a pint weight. You can find many ready-prepared slips on the market in a wide range of colours, but you still have to ensure they are in the correct condition before use. If the slip is too thick, it can give the appearance of cake decoration; if it is too thin, it will spread too much or run excessively.

Sieving the slip is essential, as lumps in the slip are likely to block the slip trailer or will give an uneven surface when dipped or poured for decorating. Allow the slip to run freely through the sieve. Using 60s or 80s gauge mesh is good for this technique,

LEFT: Slip decorated dish
Photo: by Dylan Bowen.

ABOVE: White slip terracotta body with slip-trailing
Photo: by Dylan Bowen.

but you should not force the slip through the sieve, as this will only create more lumps. You can sometimes see them on the underside of the sieve after you have used a lawn brush to push the last of the slip through. If you are having problems getting the slip to pass through the sieve, you may need to add more water to thin it before passing it through the sieve one more time before use. Don't worry if you have added too much water. Just leave the slip to stand overnight and then decant some of the water off the top, stirring gently so as not to introduce air into the mixture. You must constantly stir the slip before dipping or pouring, as settling will result in a thin film of water on the top, causing an unevenly slipped surface. I do not recommend the use of a flocculent in this case because although it will stop the water forming on the surface, it can give a false impression of the thickness of your slip. So unless you have tested it by using a pint weight and processed a fired sample, be careful.

If you want to make up your own coloured slips, a wide range of stains and raw oxides is available to add to your base slip. Stains are the most popular choice because

ABOVE: Slip decorated jug
Photo: by Douglas and Hanna Fitch, Claire Borlase.

LEFT: Tubs of slip and brushes
Photo: by Kevin Millward.

LEFT: Terracotta with brushed
and trailed slip
Photo: by Josie Walter.

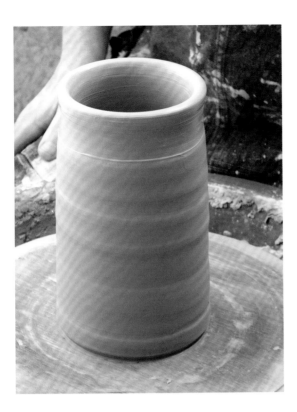

LEFT: Throwing a cylinder in clay
Photo: by Kevin Millward.

RIGHT: Brushing on slip
Photo: by Kevin Millward.

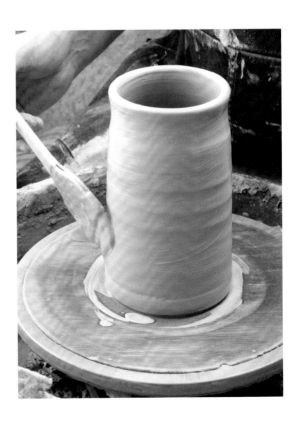

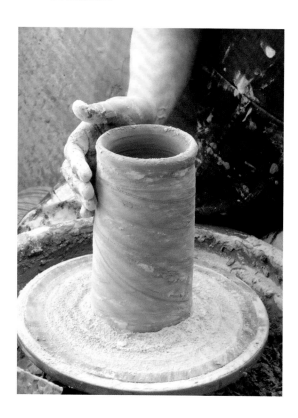

LEFT: Applying dry clay
to wet slip
Photo: by Kevin Millward.

RIGHT: Blowing out the
cylinder to stretch the
dry clay surface
Photo: by Kevin Millward.

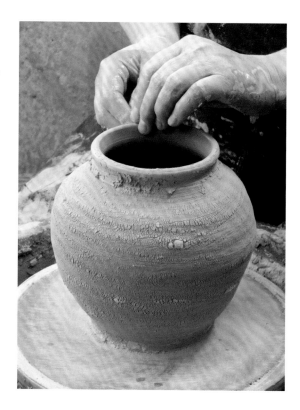

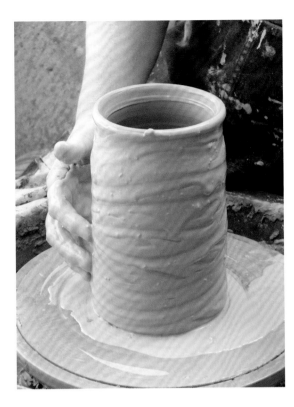

LEFT: Finger wiping
through wet slip
Photo: by Kevin Millward.

RIGHT: Blowing out form
with wet slip surface
Photo: by Kevin Millward.

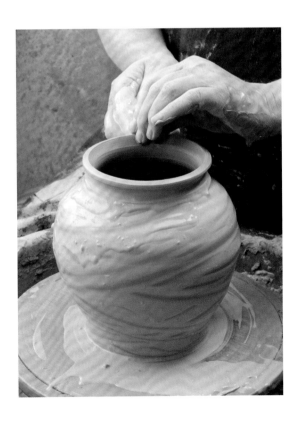

they give a more stable colour response. I have provided some recipes at the end of the book (see the appendix). If possible, use body stains alone, as they don't have a flux added to them, unlike underglaze stains. Some underglaze colours can have a deflocculating effect on the slip, owing to sodium silicate being added in the manufacturing process, but this has no detrimental effect when used as an underglaze. Many potters think stains and underglaze colours can be mixed together, but some colours can have strange effects when they are used together. So if in doubt, you must test your colours to establish their compatibility. Any reputable supplier of stains and colours will give you a recommended addition percentage of stain, which is calculated by dry weight; i.e. 10 per cent = 1 kg of dry clay to 100 g stain. If you are adding to a slip in slop form, as opposed to all dry ingredients, it is advisable to premix the oxide or stain with water, mix to a smooth paste, dilute with more water and then add this to the slip. Be aware of the firing range of the stain you are about to use, as some are affected by higher temperature firing, and some colours can change, or even worse, disappear altogether.

How do you work out how much to add to your base slip that is already mixed? You use Brongniart's Formula to calculate the dry weight of clay in a premixed slip by using the pint weight and a simple formula or by using the accompanying chart (see the appendix). You can now add stain, but if you use this method, you must stick to it because if you dry weigh the ingredient, you will probably get a different effect. So, if you require consistency in your colours, keep good notes and stick to one tried and tested method. If you are working at low temperatures, such as with earthenware, most stains will not have much effect on the flux point of your slip, but at high temperatures, as with stoneware, some stains can have a severe effect and in some instances can even cause the slip to melt. This is most evident in stains based on cobalt, so again it is essential to test rigorously before you decorate your pots. If you are using a dark-coloured clay such as terracotta, you might need to lay down a base slip first to decorate onto, with the consistency again being critical (see the slip recipes in the appendix).

It is also important to judge the compatibility of the pot as a base for the slip. If it is too wet or dry, the base pot could slake down due to the absorption of water

ABOVE: Pulling feather through wet trailed slip
Photo: by Kevin Millward.

ABOVE: Assortment of slip trailers for tube-lining
Photo: by Mark Dally.

ABOVE: Assortment of slip trailers
Photo: by Kevin Millward.

from the slip into the body of the pot, thus causing cracking or even total collapse of the pot. For some effects, it is preferable to trail straight onto the wet slip, as this allows the trailed slip to sink in, giving a level surface. If you require the slip to have a slightly raised effect, it would be best trailed onto the slip at the leather-hard stage. Decorating on the dry clay works best for fine lines, as thicker lines have a tendency to flake or peel away. Adding a small amount of flux in the form of clear glaze or frit to the slip can help with adhesion. I have successfully used a fluxed slip with the small addition of fine molochite (200s mesh) to help cut down on wet to dry shrinkage, enabling me to slip-trail onto low-fired biscuit ware.

Tube-lining

Using the techniques you have developed with slip-trailing, you can now transfer these skills to tube-lining. Fluxed slip may be required, as you will be trailing onto an almost dry surface. Many artists using this method use a pencil to draw the outline of the design on the pot free hand or use stencils. This enables them to follow the line with the fine point of the tube, often made from glass, giving a much finer line than that of the standard bulb slip trailer.

Once you have completed the design, you need to biscuit fire the pot and then fill in the design with underglaze colours. Some potters like to do what is called a hardening-on firing to about 800°C (1470°F). This ensures the colour is fired onto the biscuit surface, avoiding contamination of the glaze and preventing it from moving when glazing. Today, with modern prepared colours, this step is not always necessary, as a binding agent is added to fix the colour which does not affect the glaze as it fires. By adding an oil-based medium to fix the colour, you can handle the pot when placing in the kiln. Again, this medium must be fired out, as it would affect the application of the glaze.

It should be noted that you may find a variation in the porosity of the decorated surfaces after the hardening-on process; you can overcome the variation by adding a flocculent to the glaze. Many industrial potteries surmounted this problem by high-firing their biscuit to about 1130°C (2066°F) or higher to give an even, nonporous surface for glazing.

Feathering

Feathering is normally carried out on a flat sheet of clay, rolled out on a flat board that can be lifted without it bending. It is a good idea to have a piece of cloth between the board and clay, ensuring that the clay does not stick and to make it easier to lift it into the mould later on. The clay should be left to dry to the leather-hard stage. You should make certain the clay surface is smooth and flat, because the slip will not cover up faults but can accentuate them.

You can now pour the base slip over the rolled-out clay; this is usually a white slip but can be any colour. Just remember to ensure the slip is the right consistency. You

will need a tub or bucket to catch the slip as it runs off, so make sure you have enough slip to do this in one go. Drain off surplus slip, lay flat and allow to settle.

You can now start to decorate. This process involves applying alternating lines of different coloured slips onto the slipped surface using multiple slip trailers filled with contrasting colours. The slips can now be applied, working from the top to the bottom, away from the areas you have already decorated. When the entire surface is lined, you are now ready to feather the decoration. This process involves using a clean feather, stripped as in the illustration on page 44, to reveal a fine flexible tip which is then pulled through the wet slip in alternate directions. This technique cleans any build-up of slip from the tip of the feather, thus achieving the classic feathered decoration.

After you complete the decorating, I recommend you lift the board and the decorated slab of clay and drop it from a few centimetres height onto the bench. This

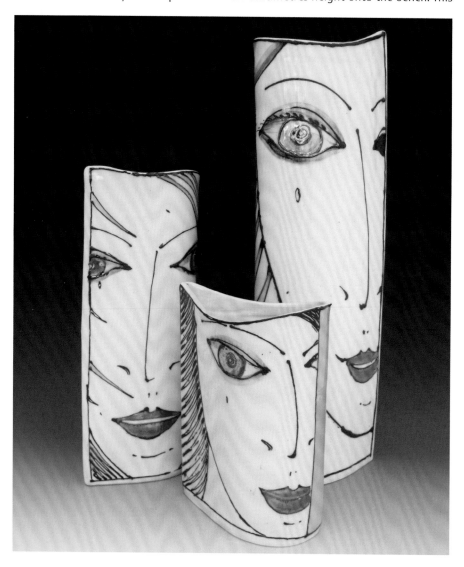

LEFT: White earthenware body with tube-lining and underglaze colour
Photo: by Jonathan Cox.

will have the effect of levelling the slip. You then can set aside the decorated sheet of clay until the surface is leather hard, which may take a day or two. When you are sure that the slip is dry enough so as not to spoil the decoration, you can then press-mould or manipulate the sheet of clay into the form you require. The decorated surface is very delicate, so if the surface is too wet, do not attempt to move the sheet of clay. Also, take great care to protect it during any making process.

Marbling

Marbling is usually carried out using two or more colours; I prefer to use three. For this process, you need a press-moulded or thrown bowl or dish at the leather-hard stage. I find it best to use a base white or cream slip for coating the surface of the pot. Taking a jug of the base slip, pour in about half the volume of the bowl. Then roll the slip around the inside surface of the bowl, making sure the coat is even up to the top edge. If you are careful when you do this, there will not be much cleaning up to do! And you also will not overwet the pot. Tip out the excess slip, leaving just enough to create a small reservoir in the bottom of the pot.

Using your slip trailers containing slip in the same condition as used for the feathering, you can now place three small dots of blue slip and three dots of black, as per the illustration on page 50, into the reservoir of white slip in the bottom corner of the pot. Picking up the pot, you can now gently rotate it, working the slips around until you achieve the desired pattern. You can now move the slip to the spot where you can empty the excess out from the edge. Tip away enough slip to ensure there is no pooling of slip in the bottom, as this can cause cracking at the drying-out stage. Clean off any overspill, as again this can lead to cracking.

Leave the pot to dry out to leather-hard stage again before attempting any more work on the pot because the surface is susceptible to damage. When the pot is leather hard, you can turn the pot if you wish or fettle the edge to remove any slip residue, being aware of the delicate nature of the surface. If the marbled slip gets marked, it is almost impossible to repair, but if debris gets onto the surface, it is sometimes possible to gently remove it but only when the pot is bone dry.

As you develop your confidence with this process, you can adjust the density of the slips, which will enable you to obtain a variety of finishes. In fact, no two patterns can ever be the same and are therefore totally unique.

Wet and dry techniques

Many single- or multi-coloured decorative surfaces can be achieved by simply dipping, pouring or brushing a slip over the surface of a pot which can then be decorated. At that point, you can make designs in the surface using tools or your fingers while the slip is still wet or use sgraffito techniques into the surface at the leather-hard stage.

A current popular technique involves adding small amounts of sodium silicate to slips. This is supplied in Twaddells (TW). I recommend 75sTW, as this does not have to be diluted and is therefore much easier to work with. When added in small amounts to a very thick slip, it will create a false fluidity. The slip can then be left to thicken through evaporation, giving it a greater density than with a normal water slip. This type of slip can be used for all the preceding techniques with the added advantage of retaining a raised pattern after drying that would normally disappear. The advantage of these marks is that they will still be evident after glazing. This decorative technique is particularly interesting when used on porcelain, as the translucency enhances the variation in slip density on the surface of the pot.

You also can achieve cracked and crazed slip surfaces by using slightly deflocculated coloured decorating slips. When they are applied to a wet clay surface, this has the effect of breaking up the surface layers of the clay beneath. Stretching and distorting the clay surface, when throwing the pot from inside, for example, will enhance this effect.

Using a thrown cylinder as a base, you can apply a whole host of slips and dry clays to its surface. When using dry clays, it is always advisable to use a dust mask. Make sure the surface of the pot is still wet. Then take a handful of dry clay and slowly rotate the wheel whilst applying the clay to the surface, moving from the bottom of the pot to the top. The clay can be fine powder, coarsely ground or a mixture of both.

BELOW: Deflocculated porcelain slip on porcelain body with celadon glaze *Photo: by Joanna Howells.*

The speed of rotation and how fast or slow you move up the pot will determine how much clay is deposited on the surface. Contrasting slips and coloured dry clays can be used for different effects, such as black slip on a white clay surface with a white clay dust over this.

You can now continue with the throwing process, but remember you can work only from the inside and must avoid touching the outside unless this deliberately forms part of the decoration. Learning to shape from inside only can take some time to master, so it may be beneficial to practise. It's worth the effort, as the results can be spectacular. It can be an advantage to let the slip dry for a while to encourage the underlying slip to crack more when shaping. The cutting or marking of the surface prior, during or after the throwing can enhance any one of these effects.

BELOW: Terracotta body with coloured deflocculated slips
Photo: by Simon Stamitiou.

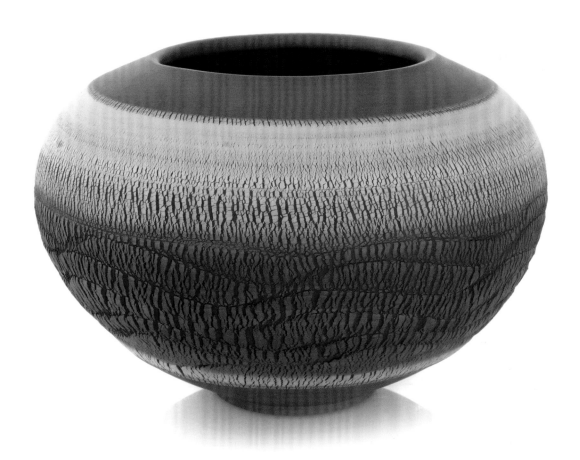

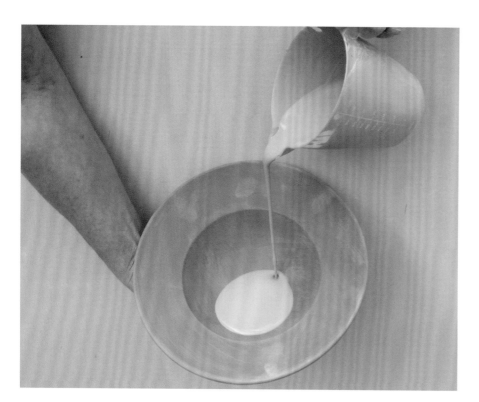

Wet slip dry clay

Wet slip leatherhard clay
Photo: by Kevin Millward.

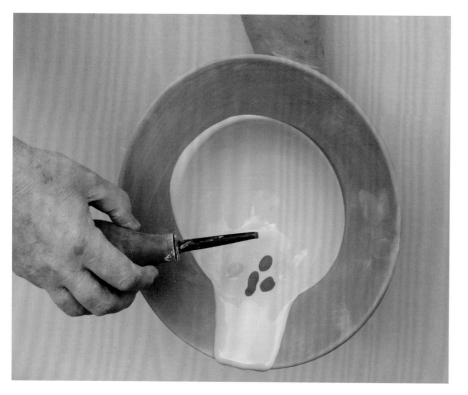

Dots of blue and black slip
Photo: by Kevin Millward.

Moving wet slip
Photo: by Kevin Millward.

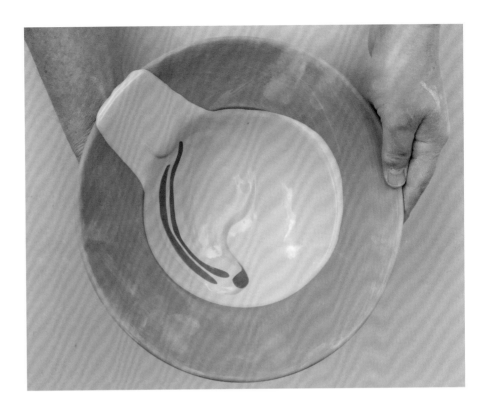

Photo: by Kevin Millward.

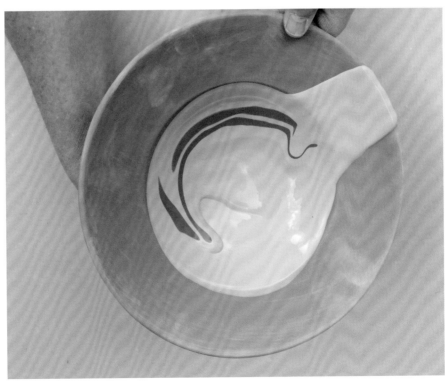

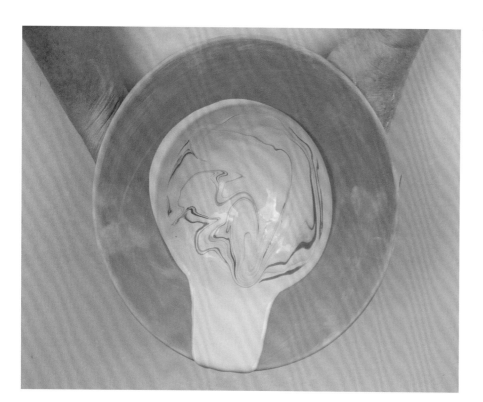

Tipping out excess slip
Photo: by Kevin Millward.

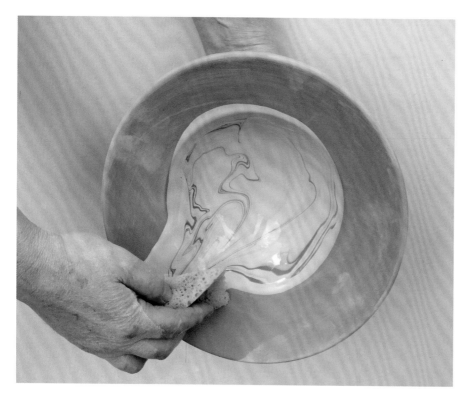

Wiping away excess slip
Photo: by Kevin Millward.

Photo: by Kevin Millward.

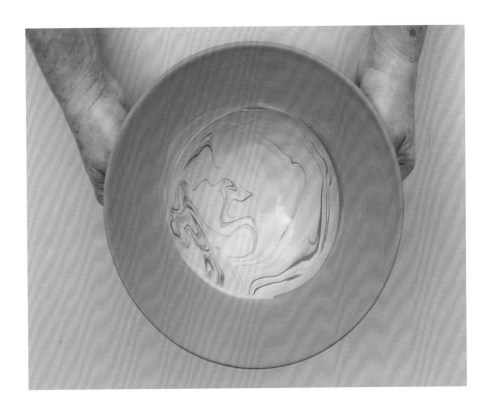

RIGHT: Cream earthenware
body with marbled
coloured slips
Photo: by Kevin Millward.

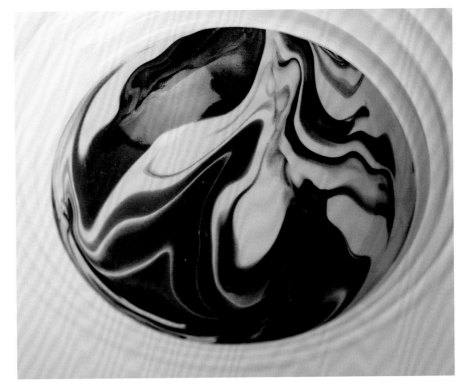

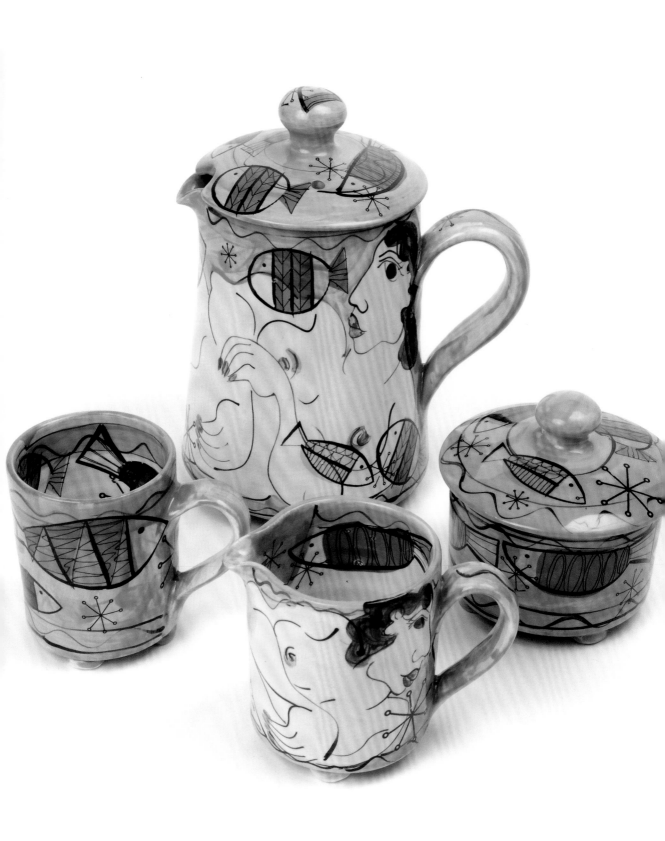

6 Painting

Maiolica

The tradition of painting on tin glaze, known as maiolica, goes back many centuries. It was popular as a way of imparting a white finish to an otherwise drab earthenware body. This technique was never more popular than when porcelain first came to Europe; it was seen as a way of imitating a type of ceramics that wasn't understood in Europe at that time. The Dutch, with their blue and white Delftware, provide a perfect example. The classic interpretation, however, is the exquisite painting on tin glaze by Italian potters.

The first thing potters are aware of when trying to paint onto dry glaze is the dusty surface and the problems created when trying to paint a fine line. This problem was overcome by adding a glaze binder into the slop glaze, which prevents the glaze from dusting on the surface. One commonly used binder is gum such as gum arabic or any preparatory glaze binder from your ceramic supplier. The way many Italian

LEFT: Underglaze decoration
Photo: by Karen Atherley.

BELOW: Brushed on oxides on a white opaque glaze
Photo: by Marshal Coleman.

ABOVE: Tin-glazed terracotta and sgraffito
Photo: by Catherine Rooke.

potters overcame the problem of the dusty surface was to sinter the glaze. This process involved firing the glaze onto the body of the pot at a low temperature, approximately 800°C (1470°F) to prevent the glaze from dusting but still retaining a high degree of porosity.

You may have to test your glaze to find the optimum temperature. I recommend using underglaze colours for decorating. If you are firing the glaze at about 1080°C (1976°F) on a terracotta body and the body of the pot has been fired to a temperature high enough to prevent crazing, there should be no problems with colours firing away. However, some bodies need to be fired to a higher biscuit temperature. Some potters find the lower porosity that a high biscuit firing creates to be a problem when applying the glaze (refer to Chapter 8 on glaze effects for more information). Problems may occur with the stability of the colours if you decide to fire to a high glaze temperature of 1125°C (2055°F), for example; you may find that some colours fire away. Testing is always recommended.

Majolica

Majolica is a lesser known technique used to great effect during the Victorian period, notably by Minton. It's believed the sixteenth century French potter Bernard Palissy was

the inspiration for this style of ceramics though there were many other manufacturers. The technique differs in that coloured glazes are painted onto a soft biscuit-fired earthenware body, making the pots susceptible to breakage. Pristine examples of mid-eighteenth century examples are therefore rare and much sought after.

In the past it was problematic to obtain the glazes suitably prepared for painting onto a porous body. With the advent of brush-on glazes, however, you will find that they are ideal for this technique (see "Brush-on glazes" in Chapter 9). The best effects are usually achieved on a more three-dimensional surface decoration with areas that can contain the fluid qualities of the glazes as they come together during the glaze firing. It was quite common for the Victorian glaze manufacturers to produce coloured glazes specifically for this process.

Brush strokes

The brush is possibly the most common implement used to apply colour to the surface of a pot. However, it also can be used as a mark maker in its own right, lending its own distinctive qualities to the surface. The marks made by the Japanese calligraphy brush are a prime example of this, where the shape and cut of the brush and the way it is loaded with colour and brought into contact with the surface give a predetermined shape and form to the stroke. The ceramics industry took advantage of this capability when a high percentage of pots were hand decorated. Brushes were made and cut to give specific shapes and forms to achieve continuity and speed when decorating a wide range of wares. In fact, the industry still refers to these tools as pencils, *brush* being a modern term.

The shape and cut of the brush is inextricably linked to the mark that it makes. You must be aware that the type of colour you are to use, the medium that will carry the

BELOW: Brushes
Photos: by Kevin Millward.

colour and the type of surface it is applied to have a great effect on how the brush can be used. The type of hair the brush is made of also is critical; i.e. brushes for painting oil and watercolours are not always suitable. The way the brush is held also affects the brush strokes, and this is especially evident when using Japanese brushes.

Oxides and colours

For centuries, potters decorated with whatever oxide was available. However, as trade routes expanded, the range of available oxides increased. Although the potter's palette could still be limited to brown, green, blue and black, these colours were used to great effect. With the development of glazes and the additions of multiple oxides, a whole new range of colours was developed. This intermixing of materials started the search for new and more exciting colours. Blending more than one oxide together,

BELOW: Slip and brushed oxides
Photo: by James Campbell.

RIGHT: Brushed on
underglaze colour on white
earthenware body with a
transparent glaze
Photo: by Karen Atherley.

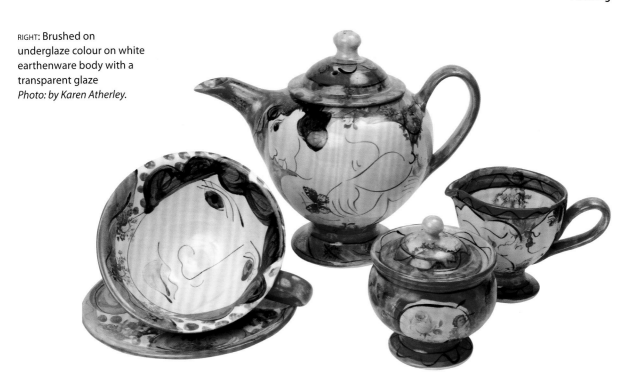

RIGHT: Brushed on
underglaze colour on white
earthenware body with a
transparent glaze
Photo: by Shelton Pottery.

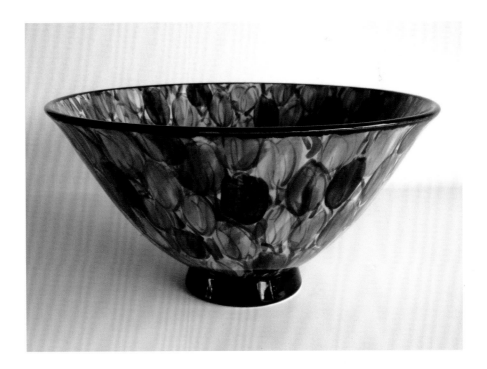

sometimes with a catalyst, and then subjecting this mixture to heat (i.e. calcining to form a new colour) in some instances created a colour that had no relationship to the base oxides (e.g. chrome and tin, which are green and white, calcined together give us pink). The drawback to using many colours has been the temperature range. So this was the reason for the rise in popularity of on-glaze enamels, as they have the widest palette of colours for their temperature range.

Many potters do not realise that all prepared colours go through the calcining process to produce a base colour. It can then be processed to produce a whole range of glaze, body stain, underglaze and on-glaze colours. After adding fluxes, recalcining, crushing, milling and grinding, they are ready for use. So what are the advantages of a calcined colour over a raw oxide? They are consistency of colour and repeatability. Many potters, though, prefer to use raw oxides when making and developing glazes, giving them their individuality. It is worth noting that most commercial glazes are ball milled to give an even mix of any colour added; to some, this makes the glaze surface uniform and bland.

Following is an example of a recipe for an underglaze green colour from the nineteenth century.

Victoria green

> Flint 5
> Whiting 3
> Arsenic 1
> Oxide of chrome 1
> Salt 1

Place colour in saggar.
Calcine in hard biscuit, i.e. about 1145°C (2090°F).

It would be fair to say that many colours are unique to specific manufacturers and available only from them. The reason is the serendipitous approaches to colour development. Many potters will say the same thing about their glaze recipes: even if they give you the formula, it never comes out quite the same for someone else.

Glaze

Painting with glaze could fall under the category of majolica, but painting a glaze onto the surface of a pot before or after firing is a tried and tested method going back centuries and across many cultures. A good example is the Whieldon ware of the

eighteenth century or the Tang horses from China. As with any of these techniques, the compatibility of glaze colour and firing temperature is essential.

With this process, you need to be aware of the movement of the glaze as you are with double dipping (see Chapter 8). If you are at all unsure, place the work on a scrap piece of kiln shelf. I have often seen a brand new kiln shelf ruined by an overenthusiastic student's liberal application of glaze. Again, I recommend looking at the wide range of brush-on glazes and effects available today. Don't feel guilty about buying a glaze; it's what you do with it that's important.

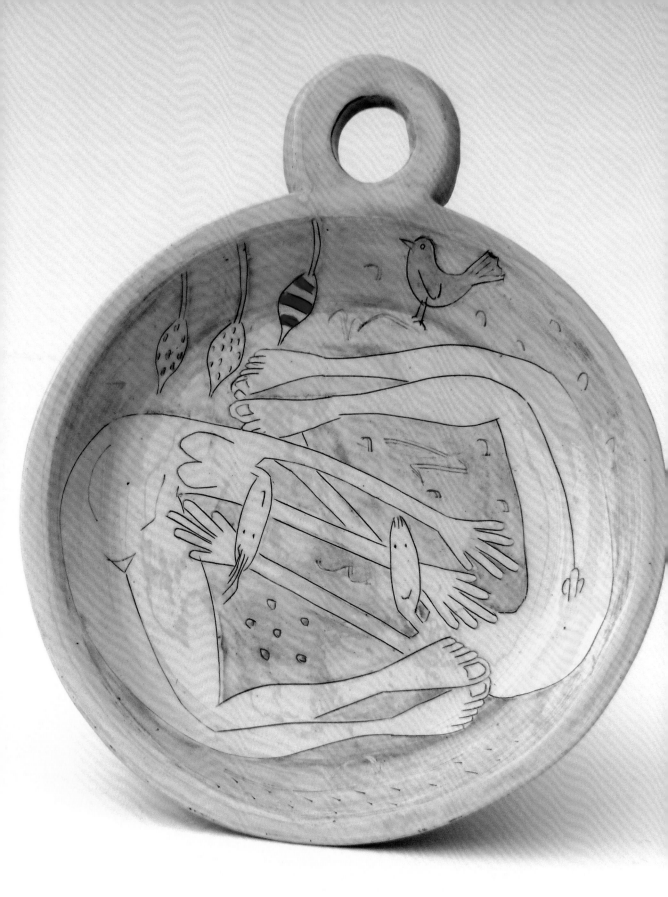

7 Drawing

Crayons and underglaze pencils

The use of crayons and pencils on biscuit ware can give a quality close to that of drawing on paper, but the application of a glaze can give a permanence and durability not associated with paper. Crayons and pencils can be used in conjunction with other decorative techniques such as underglaze painting or slip-trailing. In my experience, I find it is advisable to harden on the colours before glazing, as the dust created by the process can lead to crawling of the glaze.

The use of a clear glaze is advisable, as opaque will conceal the decoration. This technique is mostly used for earthenware but can be used on high-fired bodies, providing the colour used is stable at the higher temperatures. As long as you test its suitability, there is no reason not to have a go. A white background is best because the effect can be subtle.

LEFT: Paper stencils sgraffito
Photo: by Vivienne Ross.
RIGHT: Underglaze pencils
Photo: by Kevin Millward.

LEFT: Underglaze coloured pen
Photo: by Tamsin Arrowsmith-Brown.

LEFT: Porcelain body sgraffito through blue brush marks
Photo: by Adam Frew.

<small>ABOVE:</small> Decorated with underglaze crayon
Photo: by Miche Follano.

LEFT: White slipped
terracotta with sgraffito
honey glaze over
Photo: by Mary Johnson.

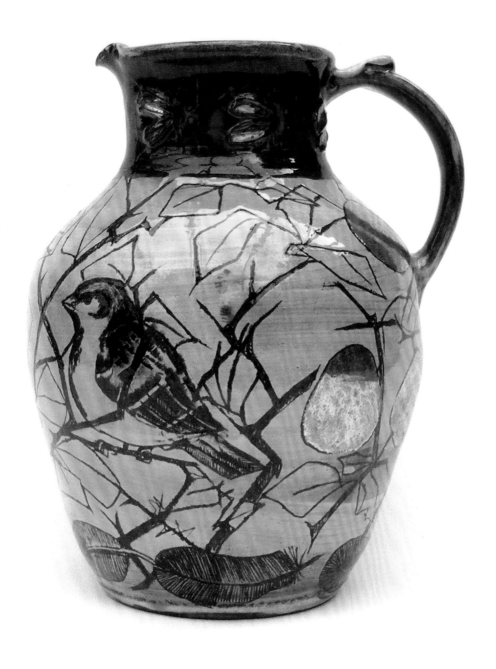

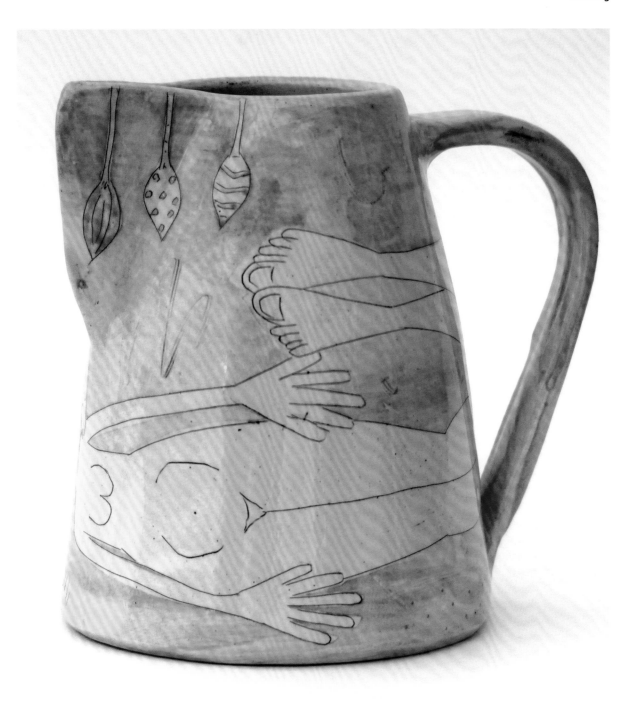

ABOVE: Slip decorated terracotta, paper stencils sgraffito
Photo: by Vivienne Ross.

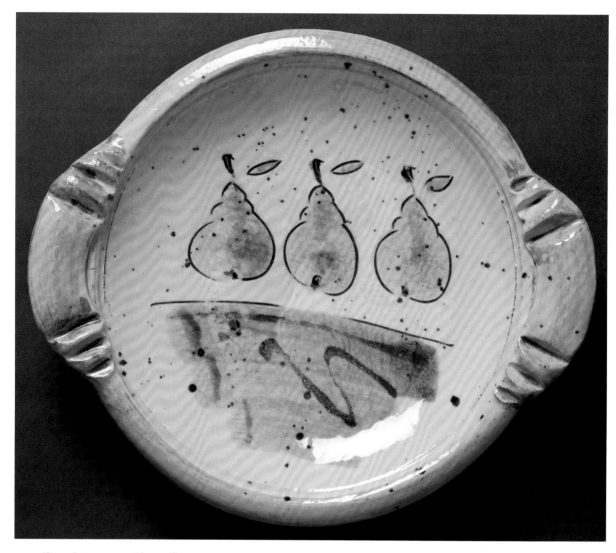

ABOVE: Slipped terracotta with sgraffito
Photo: by Josie Walter.

Sgraffito

The sgraffito technique has been used widely for generations by country potters producing classic harvest jugs. The secret of using many of these traditional techniques today is to give them a contemporary twist while sticking to the tried and tested methods associated with this process.

The technique involves covering the base body of the pot with a contrasting coloured or white slip, ensuring that it fits the body of the pot. Some slips are prone to flaking on leading edges. This result, known as shivering, does not always show at biscuit firing but can appear at glost due to the compression of the glaze. Traditionally,

this would be a terracotta body with a white clay slip applied over the top. The secret is in the timing of the application of the covering slip. If the pot is too wet, the pot may collapse; if it is too dry, the pot may slake down.

If you are press-moulding your pots into a plaster mould as opposed to pressing on a hump mould, then the mould will help support the form during the slipping phase and in drying out. In some instances, it is possible to dip ware that is completely dry— bone dry. In fact, when I have used this process, I often dry the pot over the kiln to make sure it is totally dry. This method of application allows the overdipping of more complex forms.

It is now possible to scratch back through the top layer to reveal the coloured body underneath, noting that you will get a different effect on a dry surface than that of a leather-hard pot, depending on the depth of cut and so on. This technique can be done at various stages during the drying process using a wide range of available cutting tools made from wood, plastic or metal. The additional application of slip or underglaze colours at the clay or biscuit stage can enhance the surface, and after glaze firing, it is possible to apply transfers, on-glaze enamels and lustres.

RIGHT: Monoprint on terracotta
Photo: by Jane Cairns.

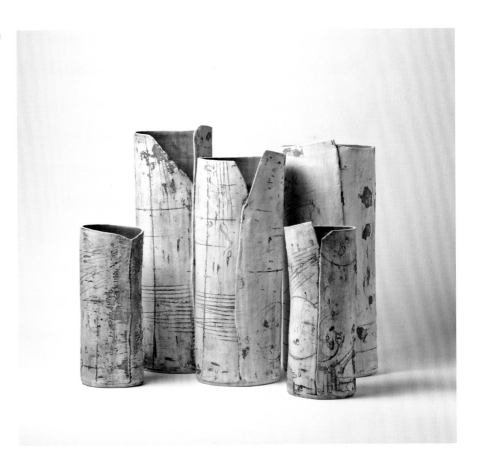

Monoprinting

Monoprinting is an interesting technique but can be quite confusing because the image needs to be reversed. You need a slab of damp plaster of Paris cast onto a sheet of glass, if possible, to achieve a smooth surface. It is best to apply the detail first by slip-trailing perhaps and then brushing slips or colours over this. It is possible for you cut through the layers of slip, as with sgraffito, back to the plaster. Beware of cutting right into the plaster, as this could leave plaster residue in the slips and create problems when fired. I therefore recommend the use of wooden tools. Slips may be applied over the area of sgraffito, which will create lines on the surface. It is advisable to dry for a while between coats to prevent overwetting.

When you have completed the decoration on the plaster, adding a light spray of water ensures the clay will stick. Now lay a sheet of clay over the decoration, making sure the clay is well pressed, and leave this to dry for a while before gently lifting the clay from the plaster. As you peel the clay back, the image should lift away. If it does

LEFT: Monoprinting
Photo: by Jane Cairns.

not lift away perfectly, do not despair, as this is a common occurrence, especially if the plaster bat is too wet; this should be accepted as part of the process. With persistence and practise, you can achieve an almost perfect image.

You also can use a hump mould to decorate onto to create shallow plates or dishes. They can be left on the mould's surface until they are leather hard. It is also possible to make small stamps from plaster and use them to print directly onto more complex forms. Again, this process can be used in conjunction with other techniques.

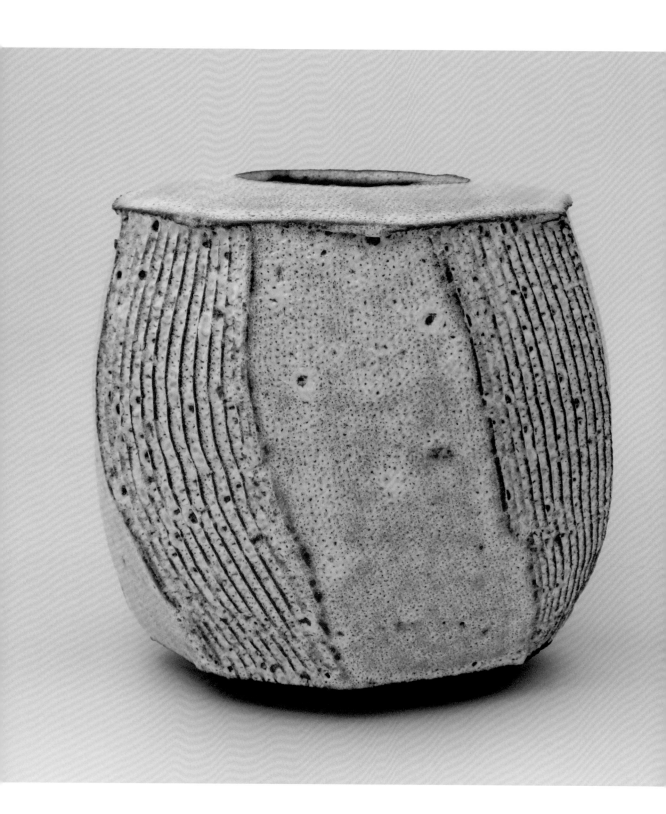

8

Glaze Effects

Silicon carbide

Silicon carbide can be added to most glazes to give a characteristic volcanic effect. The coarser-grained form is generally used, but the finer form can be used to create a localised reduction effect on the glaze in an oxidising atmosphere. The most dramatic of these effects occurs in conjunction with copper, which gives a reduction red. The recommended amount to add is between 2 and 5 per cent, which gives the most controlled effect without creating an excessively volcanic surface.

Crackle

As with many processes used in ceramics, one potter's fault is another's decorative effect. Crazing is a prime example of this, and it is probably one of the most common problems for many potters who work with white earthenware. The crazing does not always happen immediately and can start months after firing. If you want the item to be useable and watertight, the effect can present a massive problem. The most common cause for crazing is underfiring the pot at the biscuit or the glost if you hope to mature the body at the glost fire. Underfiring creates excessive expansion and contraction of the body, thus causing crazing. If you want to stop it, make sure the biscuit or glost is fired high enough.

If you want your glaze to crackle on your earthenware pot, simply underfire the biscuit pot. This is why those in the industry prefer to fire the biscuit to the maturing temperature first, then put on the glaze and fire to a lower gloss temperature. Using an alkaline frit as a base for your glaze always creates crackling, so you can use it to overcome the necessity to create crackling by underfiring. If you want the glaze to crackle on a stoneware or porcelain body, you usually can do this by adjusting the glaze. Sometimes in rare circumstances crackling can occur on stoneware and porcelain as a result of overfiring the pot. If you want to emphasize the crackled effect, it is usual to colour the crackle lines after firing by rubbing in Indian ink or a similar product. Pots fired in a raku kiln and post-reduction fired show the black lines of the crackle owing to carbon deposited from the smoke.

LEFT: White opaque glaze over black clay
Photo: by Kevin Millward.

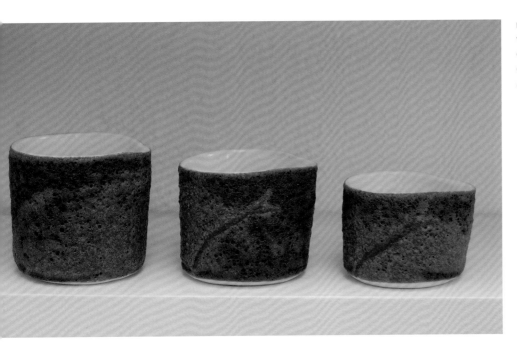

LEFT: Silicon carbide
with copper carbonate
creating red in an
oxidising firing
Photo: by Carys Davies.

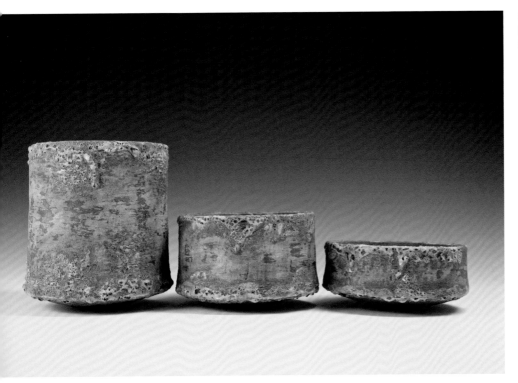

LEFT: Silicon carbide
in-glaze
Photo: by Paul Wearing.

Dry surface

In the industry, there is an adage that a dry glaze is an underfired glaze. If you want your pot to have a dry finish, it is a question of how dry a glaze you want and whether you want a matte or satin finish. You can achieve this dry finish by formulating a dry glaze from scratch or purchasing one that meets your requirements. For example, a simple but effective glaze recipe is an equal mix of potash feldspar and barium carbonate plus any oxide or stain you wish to add. This recipe works particularly well with copper, as it is alkaline in nature. If you have an existing glaze you wish to use

BELOW: Soda glazed porcelain
Photo: by Jack Doherty.

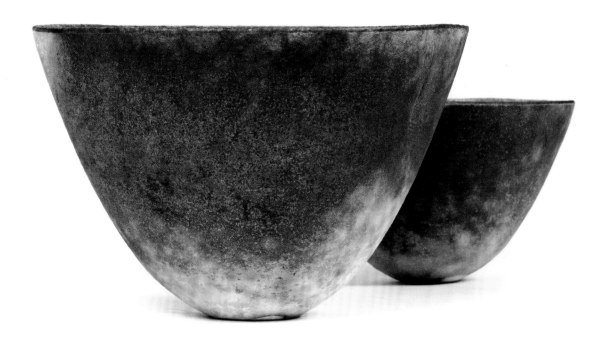

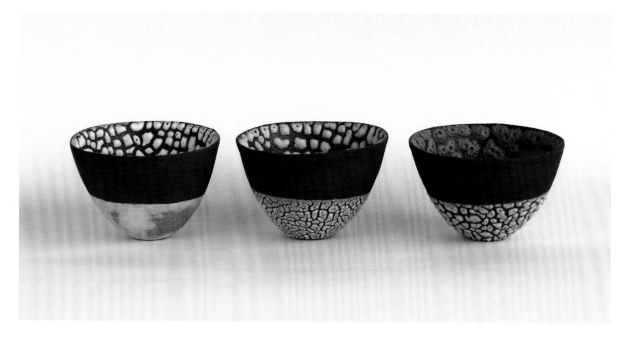

ABOVE: Controlled crawling
Photo: by Emma Williams.

as a matte or dry finish, you could just underfire it, providing the body of the pot has been fired to maturity, or you can add a preparatory matting agent from your ceramic supplier. The alternative is simply to add china clay due to its high melting point; it will increase the flux point of your glaze. Just keep adding until you achieve the desired effect. You can also approach this problem from the opposite direction by adding a flux to a clay slip, something as simple as adding borax frit, until you achieve the desired effect. It may be advisable to apply this type of slip glaze at the clay stage, or you may have problems with fit; i.e. it may start to flake off. Be aware that using a matte or satin finish for domestic or food use is not always practical.

Double dipping

The application of one glaze over another is a well-tried and tested method of glaze decoration. The two most commonly used are Chun over Tenmoku in stoneware and white opaque zircon or tin over Rockingham brown on earthenware. This technique can expand a range of glaze effects that cannot be replicated by simply mixing two glazes together. You also can purchase a wide range of glazes from your supplier as a two-glaze system that will give an effect similar to reduction firing. There is also a method that involves using a reactive slip containing a large amount of oxides, causing

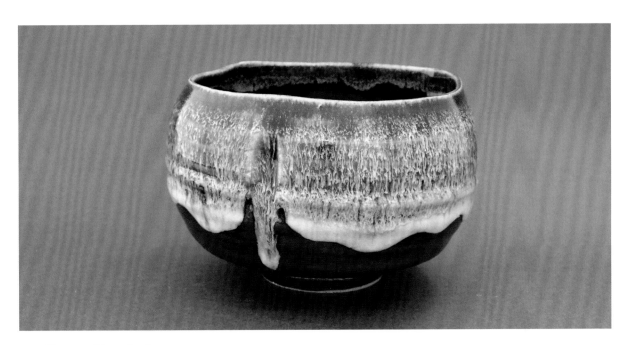

ABOVE: Chun over Tenmoku stoneware
Photo: by Kevin Millward.

BELOW: Glaze over glaze stoneware
Photo: by Suleyman Saba.

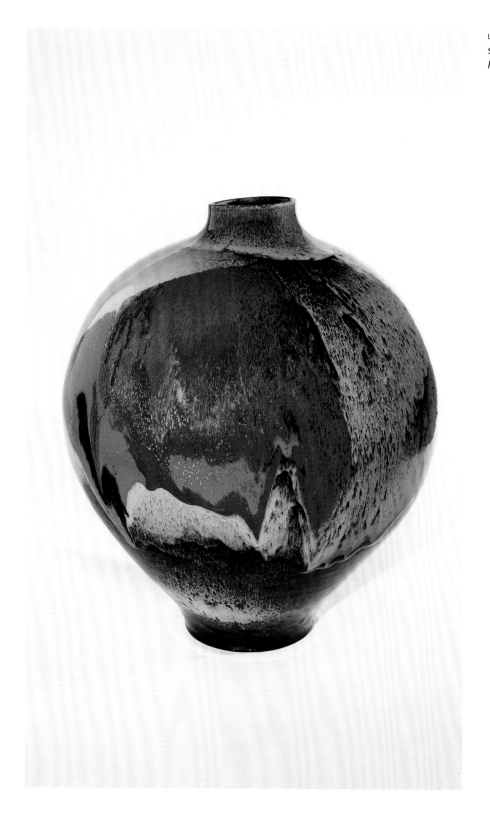

LEFT: Glaze on-glaze
stoneware
Photo: by Greg Daly.

this to bleed through the glaze laid over the top. The use of wax resist between layers is also a common one, but paper, plastic and the like can also be used. I have used various types of breakfast cereals to great effect by applying to a wet glaze surface with another glaze over the top and then removing the cereal under safe conditions to avoid creating dust before firing.

A slip trailer can be used for a more controlled effect. Be aware of the interaction of one glaze over another and the tendency for them to run due to dramatically increasing the thickness of the glaze layer. Testing the reaction is essential. Normally, the overlaid glaze comes no more than halfway down the pot, so if you intend to cover more than halfway, it may be prudent to test first, thus preventing your pot sticking to the kiln shelf. If you are at all dubious, it is always a good idea to place the suspect pot on a piece of scrap kiln shelf.

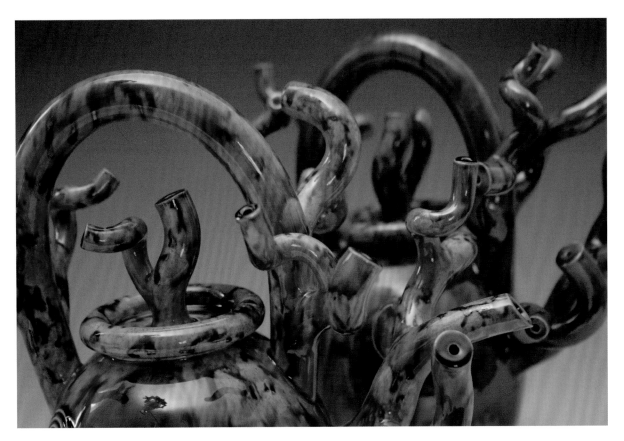

ABOVE: Whieldon glazed
earthenware
Photo: by Walter Keeler.

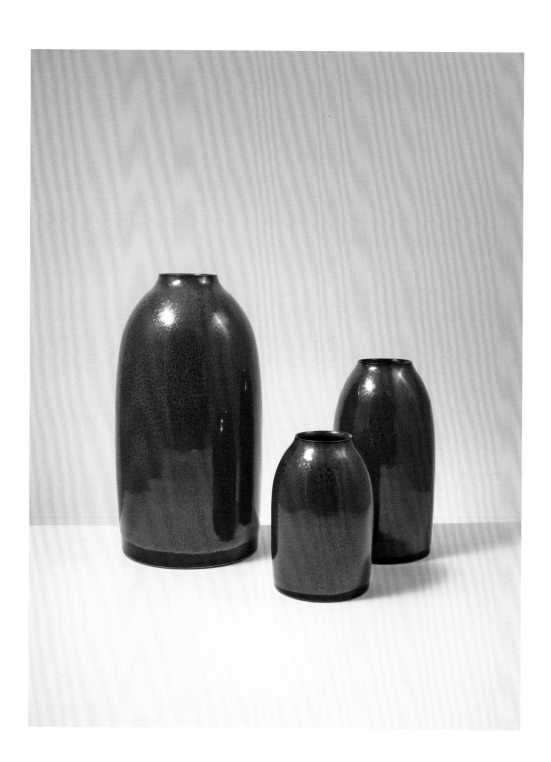

9

Glaze Application

Brush-on glazes

Brush-on glaze is a welcome addition to the technique of glaze application. Brush-on glazes solve many problems associated with glaze application, especially for the beginner. These glazes are available in small quantities, and the range of colours, effects and firing temperatures is extensive. You are able to brush the glaze onto the biscuit ware without it instantly drying on the surface. The glaze has carboxymethyl cellulose (CMC) added to it, which prevents the glaze from drying too fast by holding onto the water and allowing the surface tension of the liquid to level the glaze and remove brush marks. The only downside is that you need to build up multiple layers of glaze, as the addition of the CMC bulks out the glaze too much for it to be put down in one layer. If you don't want to buy ready-made glazes, you can add CMC to your own glazes. Contact your supplier for more information. It can also make a useful addition to small amounts of glaze used for repairing a glaze surface that has faults before refiring. Some potters are still resistant to buying glazes, but remember it's what you do with it that's important.

LEFT: Pale blue glaze over red slip
Photo: by Kevin Millward.

RIGHT: Brush-on glazes and brushes
Photo: by Kevin Millward.

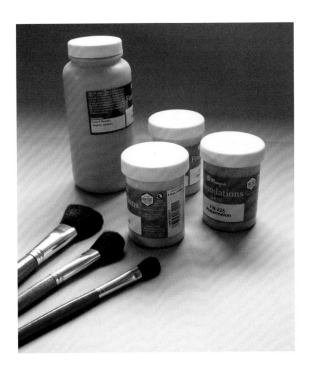

Spraying

Spraying on glazes has some great advantages but unfortunately has a major drawback in that it is realistically possible only if you have a spray booth, compressor and spray gun. I have seen some potters use crude and Heath Robinson–like apparatus such as cardboard boxes and vacuum cleaners for spraying. But you should be aware of the dangers involved, as the only safe and effective solution today is a wet-back spray booth. It is not advisable to expel glaze dust into the atmosphere because you do not know who or what the glaze dust may land on. If you are going to use the spraying method as your main method of glaze application, I strongly advise you to use an approved dust mask; doing so may seem excessive, but better safe than sorry. Assuming you now have the correct type of spray booth, you also need a compressor and spray gun. These devices used to be very expensive but are no longer excessively so. I suggest not buying an expensive spray gun, as the cheap ones do the same job. The internal parts of most guns wear out quickly due to the abrasive nature of the glaze, so it is often cheaper to buy a new gun than attempt to repair it.

To use a spray gun, you need to set up the glaze with a pint weight of about 34 ounces, and I also recommend adding a vegetable dye to the glaze so you can see where you have sprayed. This is a good idea, especially if you are spraying white glaze on a white pot. Add a flocculent to prevent the glaze from settling out in the gun and prevent glaze runs on the pot. The glaze mix can now be passed through a minimum of a 100s mesh to remove anything that may block the gun and prevent it delivering the volume of glaze required. I recommend passing the glaze through the sieve twice. The first time you can

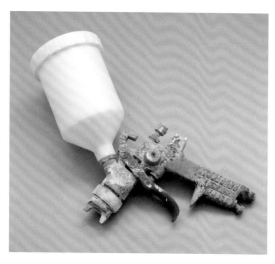

ABOVE: Spray gun
Photo: by Kevin Millward.

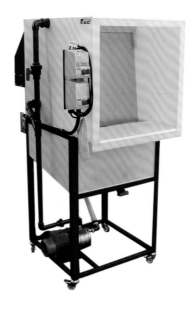

ABOVE: Wet-back spray booth
Photo: by Gladstone engineering.

use a brush to help the glaze pass through and break up any lumps. Then pass it through a second time without assistance. Spraying glazes with a built-in speckle can present a problem, as they can be sieved out or could even block the gun. For this type of glaze, I recommend using a worn-out spray gun and not sieving beforehand.

It is normal to pour the inside of the pot, as attempting to spray the inside of some shapes can cause the glaze to blow back in your face. I recommend spraying the base first (if it is to be glazed) and then placing the pot on a stilt so it is elevated to prevent build-up of glaze around the base; then spray around areas where handles join the pot. Next, you can spray the main body of the pot, making sure the gun is set up correctly for the item to be sprayed. Most guns have the facility to change the spray pattern, so consult the manufacturer's instructions. If you spray too close, you can overwet and also blow glaze off the pot. But if you spray too far away, the glaze can have a dusty appearance. You might need to apply multiple coats to avoid getting the glaze surface too wet and creating runs. If you need to respray a pot that has been glost fired, you need to set a higher pint weight and add more of the flocculent. Warming the pot is not always necessary, providing the glaze is set up correctly.

For many potters, the area giving them most cause for concern is how thick the glaze is. Cutting the glaze with a fingernail will give an indication as to glaze thickness, and you should always be aware of overglazing the pot because this can cause more problems. It is always easier to put more glaze on, but it's a bit more complicated to get too much off!

The advantage of spraying is that you can glaze a wide range of both simple and complex forms without having to make up vast quantities of glaze. With good housekeeping, you can reclaim most of the overspray when using a wet-back spray booth. This equipment can also be used to spray a whole range of ceramic materials from on-glaze colours, underglaze colours and lustres with a smaller and finer spray gun, usually referred to as aerographing.

If you are spraying dark-coloured glazes, it is best to have two guns: one for coloured glazes and slips, and one for white glazes and slips to prevent cross-contamination, especially in the case of cobalt!

Glaze application

For most potters, the physical application of a glaze to a pot can be traumatic when they realise that making a mistake with the glazing can mean disaster. It is difficult enough to think about the aesthetic considerations of the glaze and what it will hopefully look like, let alone the physical application of the glaze. Most experienced potters have honed the craft of applying the glaze by trial and error. This, however, does not help the potter who is just starting out.

How do you set about working out what is the best method for application of the glaze in your situation? You need some rules to work with. Because the process of setting up a glaze before application is so rarely taught today, where is a good place to start? How much glaze do you put on a pot? What is the right amount?

The thickness of a glaze will vary according to the glaze and type of body it is applied to. So the correct thickness can be established only after testing, e.g. after biscuit firing the pot to the required temperature and the pint weight of glaze is set. If you are unsure about the glaze thickness, I suggest you fire the pot on a piece of scrap kiln shelf.

If you are just starting to glaze on your own for the first time and have no one at hand to help, this is how you commence making up your glaze. Always put the water in the container first; then add the dry glaze materials to the water so as not to create dust. This can be done under extraction or by using a damp cloth over the container.

How much water? It is better to use too much, as this will aid the mixing of the glaze. When it is fully mixed, you should sieve the glaze. I recommend you use at least a 100s to 120s mesh and pass the glaze through twice. The first time you can use a brush to help push the lumps of glaze through, but do not force the glaze on the second pass, as this can create lumps. Now let the glaze settle to remove any excess water. You can then set the pint weight of the glaze; this will determine the amount of glaze to be deposited on the surface of the item. The pint weight refers to the amount of dry glaze suspended in a given amount of water, i.e. a pint. This information can be used in conjunction with Brongniart's Formula to calculate the dry addition of oxides or stains to a slop glaze.

The weight of a glaze is specific to the size and shape and, most importantly, what biscuit temperature the pot was fired to and its porosity or lack of it. As a rough guide, the higher the biscuit temperature, the higher the pint weight. A standard stoneware glaze that you would dip onto a mug, for example, biscuit fired at 990°C (1815°F) would be approximately 32 ounces for one pint of glaze. If you dip this glaze onto the pot, glaze fire it and the glaze is too thin, you would know that you need to increase the pint weight to, say, 33 ounces per pint. This would involve removing water or adding more glaze material. If the glaze is too thick, then you would need to reduce the pint weight to, say, 31 ounces, which would be achieved by adding more water.

How do you set up to use a pint weight? Simply take a pint container such as an old glass milk bottle, or you can buy a pint can from your supplier. First, counterbalance the container on your scales so that it weighs zero. Now stir the glaze to make sure the ingredients are well mixed. Decant one pint of glaze into your milk bottle or container and place on the scales. This will give the weight of the glaze in ounces. With this information, you can adjust the glaze. If you did not know this technique, you would require a great deal of experience, and you would not know how much glaze you had suspended in the water. The pint weight can be used for all methods of glaze application.

If you have problems with a glaze settling out or you have problems with a glaze running, you can add a flocculent to it. This will prevent settling and also improve the way the glaze holds onto the surface of the pot. With the right pint weight and the addition of enough flocculent, you can dip a biscuit that has been vitrified, as in the case of bone china that is biscuit fired at 1260°C (2300°F). The two most commonly used flocculants are Epsom salts and calcium chloride. Many potters add clay such as bentonite to do a similar job, but the disadvantage with this technique

is that you cannot remove it because it becomes part of the glaze mix. Flocculants can be removed because they are soluble in water. So by adding water to the glaze and letting the glaze settle, you can then decant off any excess water, and you will remove a quantity of flocculants along with it and then replace with fresh water.

It is possible to measure the fluidity of the glaze through the use of a torsion viscometer, but as most potters don't have access to one, an alternative is to use a hydrometer. Many potters use them instead of the pint weight system. The use of one or more of these systems can prevent many of the problems associated with glazing.

Another common problem when glazing is the propensity for glazes to be knocked off on the edge so, as discussed in the section on maiolica in Chapter 6, adding a glaze binder such as gum arabic or a preparatory glaze binder from your supplier can help alleviate this problem.

Dipping

For the majority of potters, dipping is probably the most efficient way to obtain the high-quality finish required and is the most commonly used method of glaze application. Unfortunately for many potters today, it has one major drawback in that the amount of glaze required to dip the pot into can be many litres, so the bigger the pot, the bigger the buckets and the more glaze you require, and the majority of this glaze will never be used. So the first consideration is whether you have enough glaze and if the container is big enough to take any displacement if there is any. Items such as large narrow-necked vases, where the inside has been poured and the outside must be dipped, can displace a large amount of glaze.

Once you have your glaze mixed and have the quantity required, you can set the glaze to the correct pint weight, which you have previously determined by testing. For example, say you determined a high pint weight for the smallest pot that you will dip first. When you are done with the smallest pots, you can reduce the pint weight for the next size of pot. This is done for each size of pot up to the lowest pint weight for the largest item.

As you gain experience in glazing, you will find that you get a feel for the glaze and the consistency that you are using—so much so that your reliance on the use of the pint weight will wane. However, you should never become complacent, as it can give you problems due to over or under application of glaze.

The way the pot is held during the dipping process can give great cause for concern, especially where the fingers physically come into contact with the pot. There are a number of ways of getting over this problem. For example, you can use dipping tongs, claws or finger stalls (see illustrations). The next thing to be aware of is how to get the pot into the glaze. Also, how will you get it out? That is, is there enough space to rotate the pot in the container so as to allow the glaze inside to pour out? Otherwise, you may have to lift the pot full of glaze out of the container so as to enable you to empty it. This is not easy if it is a big pot. And don't forget that all the time the pot is in the glaze, the amount of glaze taken up increases (another reason for the use of

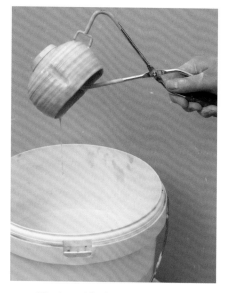

ABOVE: Dipping with glazing claw
Photo: by Kevin Millward.

ABOVE: Dipping with finger stalls
Photo: by Kevin Millward.

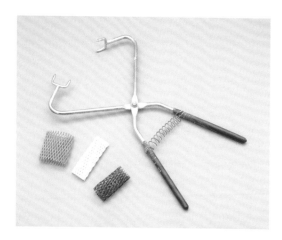

LEFT: Glazing claws and
finger stalls
Photo: by Kevin Millward.

high biscuit in the industry). Once you remove the pot from the glaze, have you got somewhere to put the pot down? You would be surprised how many people dip a pot and do not know where to put it down. It is a good idea to rehearse the process before committing the pot to the glaze.

Pouring

The advantage of the pouring technique is that it does not require large amounts of glaze, as with dipping. However, it does require a degree of skill in preparing the

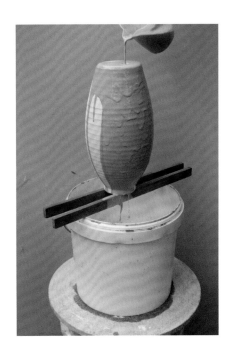

RIGHT: Pouring glaze
Photo: by Kevin Millward.

equipment and setting up the glaze. Sieving and setting the correct pint weight are essential. I usually go for about 32 ounces, but if it's a very big pot, I may go as low as 29 ounces. This latter measurement could be a better option, as you will be less likely to apply too much glaze.

In most cases, the glaze is applied to the inside of the pot first. Be sure to clean off any overspill first and be aware of not overwetting the pot when removing the glaze, as this will compromise the porosity of the rim, especially if it has a very thin edge. If in doubt, leave it to dry off. Now you will have to support the pot so as to be able to pour the glaze over the outside. You might need to wax the base, or if there is a deep foot ring, you will have to blow out the glaze from the recess. This must be done while the glaze is still wet, so as not to form runs or drips. If you wish the foot to remain glazed, you can leave it to dry. When it is dry, remove the glaze by using a wet sponge.

I recommend the setup as above. Use a bowl, bucket or some type of receptacle to receive the glaze, placed on the whirler. I have even used a plastic dust bin lid for large dishes and bowls. Also use sticks of some kind to rest the neck or rim of the pot on (sticks with a thin edge are better), taking care not to chip the rim. If the pot has a narrow top or neck, be careful that it does not topple over. You can use a stick to put inside the neck if you think the pot is unstable. For this, you can use a lump of stiff plastic clay to put the stick in and then place this in the receptacle you are using to catch the glaze. You can retrieve the clay after washing off the glaze. I recommend that you make sure the glaze is dry to prevent damaging the glaze before removing the pot from the apparatus. If you find you have too much glaze on the top edge, you may have to rub this back to an acceptable level. Remember to wear a mask or work under extraction because of the dust.

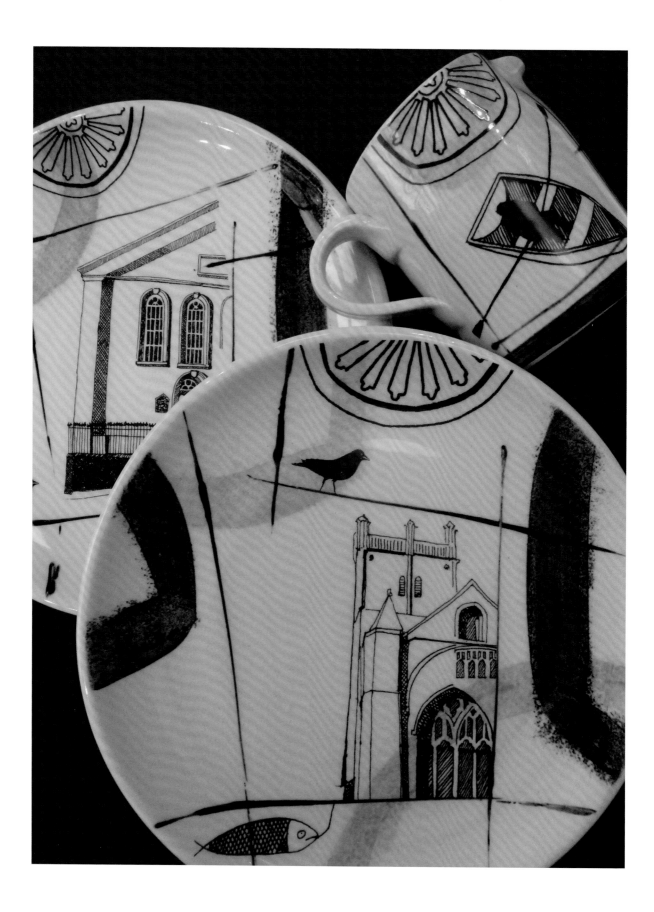

10

On-glaze Techniques

Lustres

In Islamic countries, lustre decoration has been used for centuries on tin-glazed ware and tiles, involving a low temperature reduction atmosphere at about 795°C (1463°F). Most people don't have the time, knowledge or facilities to fire in this way. The ceramic industry prized the lustre effects achieved but didn't want to use the unstable methods required to achieve them. Instead, they developed their own system of lustre application and firing that created its own reduction atmosphere in an electric kiln. This does not mean you should not have a go at the traditional methods if you have access to the facilities.

The most commonly used lustres are gold and platinum, which are mainly used to provide an accent line to the edge of a pot; for many potters, this is the first introduction to using lustres. All the rules that apply to the application of precious metals apply to the application of lustre.

The initial cost of lustres can be one of the main considerations in the selection and use of some colours, as they are based on precious metals and can be very expensive. Mother of pearl is probably the exception; it is one of the more affordable lustres and comes in yellow, blue, and clear and is very effective when laid over a coloured glaze. An important consideration that many potters are not aware of is that the shelf life of some of the lustres is limited, so it is advisable to check before purchasing a large quantity to ensure you can use it within its shelf life. Once it has turned to a jelly-like substance in the bottle, it cannot be revived.

Preparation

Lustres demand more extreme levels of cleanliness than most decorative processes, as any hint of dust or grease will affect the finish. I recommend decorating the pot as soon as possible after it comes from the glost firing, as the pot will never be cleaner! If this is not possible, remove all traces of surface contaminants by using a solvent such as alcohol. It must be applied with a lint-free cloth and will evaporate from the surface and hopefully will not leave a residue. If you must touch the pot, do so on a surface that is not to be decorated. You can use gloves, but they must be dust and lint free.

Application

Use only good-quality brushes; your supplier should be able to recommend the best type for the intended use; i.e. a cut liner for the application of gold and silver to the rim of a pot. It is best not to mix brushes from one lustre to another unless you are

LEFT: On-glaze transfers
Photo: by Daniel Wright.

Gold
Photo: by Potclays Ltd.

Platinum
Photo: by Potclays Ltd.

Copper
Photo: by Potclays Ltd.

ABOVE: A selection of some of the coloured lustres available

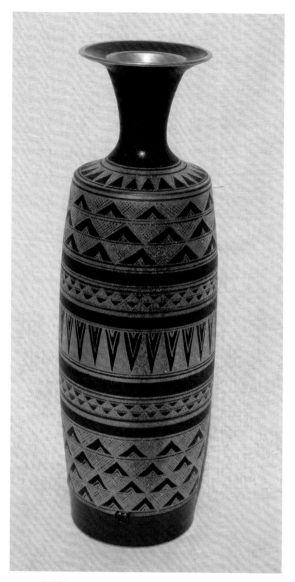

ABOVE: Gold lustre on porcelain with blue ground
Photo: by Mary Rich.

accomplished at brush cleaning. I do not recommend thinning the lustre unless your supplier has advised you to do so, as this can greatly affect the finish. Overapplication of the lustre can be one of the most common causes of lustre flaking off. Underapplication can cause a scumming on the surface, commonly referred to as purpling. This effect is common when using gold-based lustres. Large surface areas are a complex problem. You should attempt the spray application of lustre (aerographing) only if you have the appropriate extraction equipment. A very strong smell is associated with the application of lustres, so it is important to work in a well-ventilated area.

Techniques and effects

You can mask out an area by using a proprietary masking agent, but you can use anything that prevents the lustre adhering to the surface. The surface can be deliberately distressed by flicking lustre thinners or turpentine from a stiff brush. There is also a range of effects available from your supplier.

You also can purchase precious metals in a form that can be screen-printed or painted onto pre-cover-coated thermoflat paper. Using this method can be expensive, as large amounts of gold can be wasted. However, some companies specialise in reclaiming waste gold.

Transfers

Over the past few years the introduction of digital transfers or decals has revolutionized the use of transfer printing and decoration. Although the equipment for the production of transfers is very expensive currently, the advent of digital printing companies into the marketplace has made this method an economical alternative to many of the standard methods of printing. Previously, the only other economical method available was screen printing, but the production could be prohibitively expensive for short

BELOW: Bone china with blue transfer print on-glaze burnished gold
Photo: by Flux Versatility.

runs unless you had access to your own screen-printing facilities. Open stock transfers that are printed in a wide range of styles and genres are available to purchase in small quantities. It is also possible to buy cover-coated thermoflat paper that you can paint or print onto (i.e. using lino print) so long as the printing medium is compatible with the cover coat. You also can purchase sheets of preprinted colour and cut out shapes.

The cover coat has a degree of flexibility when new. In fact, very new transfers can be problematic, as the cover coat is too soft, but if it is old, it can be brittle. I recommend that you warm the pot (not too hot) and then put a tiny spot of washing-up liquid into tepid water. Soak the transfer in water until it has penetrated through the back of the paper (you will see it change colour). Then remove it from the water to drain by laying it down on a water-proof surface; I use a cheap plastic tea tray. Don't leave transfers in the water, as you will deplete the gum on the transfers, reducing the ability to stick to the pot, or you could even get the transfer on back to front. You also need a small soft rubber squeegee (referred to as a kidney) and a lint-free cloth. Apply the transfer with care, as they are easily damaged or overlapped.

In some instances, if you have a complex shape, you may have to cut and fit a print. This can be a problem if you have an area of colour lying over another piece of cover coat, which causes frazzling. This effect is commonly caused by badly applied transfers with water trapped under the print, so it is best to allow the pot to dry overnight.

It is essential that you have a slow rise in temperature during firing, leaving time for moisture to escape and the cover coat to soften and burn away without affecting the colour underneath. Make sure the kiln is well ventilated when burning off the cover coat, as in rare circumstances, a reduction atmosphere can develop in the kiln if it is not well vented in the early stages of the firing, thus affecting the glaze and colour.

A method of printing used before the advent of water slides was the tissue paper method. This method entails printing onto a specially made tissue paper using an engraved copper plate with underglaze colour applied to it and then applying a size (a type of glue) to the surface of the biscuit ware. You then cut out the transfer, apply it to the surface, and rub it down with a stiff brush, making sure the tissue is attached to the biscuit ware. The ware is then soaked in water to dissolve away the tissue paper, leaving the colour on the surface. Because it has been printed in an oil-based medium, it is not affected by the water.

The biscuit has to be fired again to about 805°C (1481°F) commonly referred to as hardening on. This fires the colour onto the biscuit pot, and the ware can now be glazed. This process has many possibilities for different types of printing methods that can be achieved at home or in a small studio. The only company still decorating commercially in this way today is the Burleigh Factory in Stoke-on-Trent.

On-glaze enamels

On-glaze enamels are any colours fired onto a glost surface. The firing range can be quite wide, depending on the stability of the colours used and the ceramic surface you intend to fire onto, e.g. earthenware or porcelain.

Blue
Photo: by Potclays Ltd.

Green
Photo: by Potclays Ltd.

ABOVE: A selection of some of the coloured lustres available

ABOVE: Slip over terracotta blue brush marks screen-printed on-glaze transfer in black
Photo: by Daniel Wright.

What constitutes an on-glaze colour? It is a colour that has enough flux added to form its own gloss. Historically, enamels were popular because the palette of colours available was much wider due to their low firing temperature. They also worked well combined with the soft lead-based earthenware glazes. Some potters forget or do not realise how important the glaze itself is in developing the quality of shine on the fired glaze colour; for example, colours applied to a matte glaze do not always develop a sheen of their own. Colours cannot be put on all at once, and the more complex the decoration, the more firings you have to do. Applying on-glaze colours involves laying down the high-firing colours first and then working down to the more sensitive colours, finishing off with precious metals.

To prepare your colour, mix with fat oil (reduced pure turpentine); then thin down for painting with pure turpentine. If you use too much, the colour will have a tendency to run, so if you wish to dilute or reduce the intensity of the colour (as in a wash of colour), you have to use other types of oil such as aniseed or clove. If you have ever visited a ceramic decorator's studio, you would be very aware of the pungent smell of the oils used. One of the main reasons for using these oils is that when they

BELOW: Hand-painted on-glaze enamels applied to bone china with burnished gold *Photo: by Peter and Marie Graves.*

evaporate, the residue bonds the colour onto the glazed surface and does not damage the decorated surface.

I recommend testing the colours and medium to be used before beginning to decorate. Before attempting any form of on-glaze firing, check the suitability of the ware you intend to decorate. That is, determine the type of glaze on the pot and whether earthenware or stoneware, as this will affect the way the colour fires onto the surface. Is the body of the pot porous or vitrified? How old is the pot? When was it gloss fired? If the pot is porous and has been standing around for just a matter of weeks, it can absorb moisture from the atmosphere. Or even worse, has it been in a dishwasher? When a pot of any age is subjected to a refire at a low enamel temperature, it can cause what we call spit-out, commonly known as sugaring. This is caused by moisture bursting through the soft glaze layer at enamel temperatures as super-heated steam. The only way to remedy this is to refire the pot again to gloss temperature, which unfortunately would also fire away much of your decoration. If you are in any doubt and you are able to, refire **before** you decorate. If your pot is totally vitrified, say in the case of bone china or porcelain, problems can still occur. For example, you might have carbon trap, which manifests itself as a grey shadow under the glaze, usually around the foot ring. Be careful if you buy your pot and don't know what type of glaze it has and how old it is. The only sure way is to test, test, test!

Appendix

Brongniart's formula

$$W = \frac{(p - 20) \times g}{g - 1}$$

Where W = Imperial/US/Metric measure of dry material in one pint of slip
 g = specific gravity of dry material (usually 2.5 for clays)
 p = pint weight in Imperial/US/Metric measure of a specified volume of slip

Pint weight (UK imperial measure only)

Dry content of one pint of clay slip at various pint weights

Slip weight (oz/pint)	Dry content (oz)	Specific gravity (SG)
20	0.00	1.00
21	1.67	1.05
22	3.33	1.10
23	5.00	1.15
24	6.67	1.20
25	8.33	1.25
26	10.00	1.30
27	11.67	1.35
28	13.33	1.40
29	15.00	1.45
30	16.67	1.50
31	18.33	1.55
32	20.00	1.60
33	21.67	1.65
34	23.33	1.70
35	25.00	1.75
36	26.67	1.80
37	28.33	1.85
38	30.00	1.90
39	31.67	1.95

Slip Recipes

Standard white slip

60% ball clay
40% china clay
The iron content of some ball clay will affect the colour of stains added.

Terrasigillata

Recipe 1
1.5 kg dry clay
8 L distilled water
7.5 g sodium hexametaphosphate
Mix well.

Recipe 2
3 kg ball clay
3/4 tablespoon sodium silicate 75 TW
3/4 tablespoon soda ash
Mix well.

Place mixture in a clear plastic disposable bottle and allow to settle for two or three days. You will then see three distinct layers. Place the container over a bucket and pierce below the water level. Dispose of the water. Then pierce at the level above the heavy parts of the clay; this is the slip to use.

Temperature Conversion

To convert °C into °F: Multiply by 9, divide by 5, and add 32.
To convert °F into °C: Deduct 32, multiply by 5, and divide by 9.

Glossary

Agate A mix of different coloured clays giving a marbled pattern.

Aniseed Oil Medium used in on-glaze painting.

Ball Clay A fine, plastic clay, usually firing white or off-white.

Banding Wheel A turntable operated by hand and used for banding and decorating.

Bat A plaster or wooden disc for throwing or moving pots without handling or for drying clay. Sometimes used to refer to kiln shelves.

Bat Wash A mixture of alumina and china clay used as a protective coating for kiln shelves.

Biscuit Firing The first firing of pottery before glazing.

Body A term used to describe a particular mixture of clay, such as stoneware body or earthenware body.

Burnishing The process of polishing leather-hard clay using smooth pebbles or spoons to achieve a shiny surface.

Calcined The heating of a compound or oxide to create a new and stable colour.

Casting Making pots by pouring liquid clay into a plaster mould.

Casting Slip A liquid slip used in the process of making objects using plaster moulds.

Ceramic Any clay form that is fired in a kiln.

China Clay Kaolin, a pure white burning, nonplastic, bodied clay used in combination with other clays or in glazes.

Chamotte Continental term for fire clay grog.

Chun Pale blue firing stoneware glaze.

Clove Oil A medium used in on-glaze painting.

Coiling Forming a pot from coils or ropes of clay.

Combing A method of decoration using the fingers or a toothed tool to scrape a series of lines through slip.

Cover Coat Plastic film printed over colour in transfer printing.

Crazing The development of fine cracks caused by excessive expansion and contraction of glaze. Usually due to underfiring of body.

Dipping Applying a slip or glaze by immersion.

Deflocculate To make a liquid more fluid without the addition of water.

Earthenware Pottery fired to a relatively low temperature. The body remains porous and usually requires glazing if it is to be used for domestic ware.

Elements The metal heating coils in an electric kiln.

Enamels Low-firing commercially manufactured colours that are painted onto a fired surface and refired to melt them into the glaze.

Fat Oil Reduced pure turpentine, a medium used in on-glaze painting.

Feathering A decoration made by drawing a sharp tip through wet slip.

Firing The process by which ceramic ware is heated in a kiln to clay or glaze to maturity.

Firing Cycle The gradual raising and lowering of the temperature of a kiln.

Flocculent Something that is added to make a liquid less fluid.

Foot Ring A circle of clay that forms the base of a pot.

Frazzle A fault in on-glaze transfer printing when ware is fired too fast, causing the cover coat to crawl, thus causing damage to the image.

Glaze A thin glassy layer on the surface of pottery.

Glazed Glaze applied but not fired.

Glaze Stain Commercially manufactured colourant added to glaze.

Glazing Claw A tool to hold ware for glazing.

Glost Glazed and fired ware.

Green Ware Unfired clay ware.

Grog Fired clay that is ground into particles, ranging from a fine dust to coarse sand. When added to soft clay, it adds strength, resists warping and helps reduce thermal shock.

Hand Building Making pottery either by coiling, pinching or slabbing.

Incise To carve or cut a design into a raw clay surface.

In-glaze Decoration applied to the glost surface and then refired to glost temperature again.

Kaolin See *china clay*.

Kidney A kidney-shaped scraper of metal, plastic, wood or rubber.

Kiln A device in which pottery is fired.

Kiln Furniture Refractory pieces used to separate and support kiln shelves and pottery during firing.

Kneading A method of de-airing and dispersing moisture uniformly through clay to prepare it for use.

Latex A rubber-based glue that can be used as a peelable resist when decorating pottery.

Leather Hard Clay that is stiff but no longer plastic. It is hard enough to be handled without distorting but can still be joined.

Lustre Metallic salts added in a thin layer over glaze to produce a lustrous metallic finish.

Maiolica The name given to tin glaze earthenware with decoration.

Majolica The term given to painted, coloured glaze on earthenware.

Molochite Grog made from calcined kaolin; china clay for use in white firing bodies.

Mould A plaster former used with soft clay.

On-glaze Colour See *enamels*.

Pencil A brush used in the ceramics industry.

Plastic Clay Clay that can be manipulated without losing its shape.

Porcelain Fine, high-firing white clay that becomes translucent when fired.

Potter's Plaster Plaster used for making moulds. It hardens by chemical reaction with water. Also called plaster of Paris.

Press Moulding The process of pressing slabs of clay into or over moulds to form shapes.

Props Tubes of refractory clay used for supporting kiln shelves during firing.

Pyrometer Equipment for reading the temperature in a kiln.

Refractory Ceramic materials that are resistant to high temperatures.

Resist A decorative medium such as wax, latex or paper used to prevent slip or glaze sticking to the surface of pottery.

Ribs Wooden or plastic tools used to lift the walls of thrown pots.

Rockingham Glaze A dark brown iron manganese earthenware glaze.

Saggar A refractory box used to protect ware from direct flame.

Sgraffito The technique of scratching through a layer of clay, slip or glaze to reveal the colour underneath.

Short The term used to describe soft clay lacking in plasticity.

Sinter A powdered material formed into a solid, porous mass by heating.

Slabbing Making pottery from slabs of clay.

Slip Liquid clay.

Slip-trailing The method of decorating with coloured slip squeezed through a nozzle.

Soak To allow the kiln to remain at a specific temperature for a set time.

Soft Soap A semi liquid soap used to form a release in mould making.

Spit-Out (Sugaring) Pitted surface on enamelled ware due to moisture escaping through the softened glaze layer.

Sponging A decorative method of applying slip and glaze or cleaning the surface of pottery before firing.

Spray Booth Equipment for extracting dust from glaze spraying.

Sprig A moulded clay form used as an applied decoration.

Stains Unfired colours used for decorating pottery or a ceramic pigment used to add colour to glazes and bodies.

Stalls (Finger Stalls) Devices to put on finger ends to aid glazing.

Stilts A small stand used to support pots in firing to prevent glazed surfaces coming onto contact with the kiln shelf.

Stoneware Vitrified clay, usually fired above 1200°C (2190°F).

Sugaring See *spit-out*.

Tenmoku A high iron stoneware glaze firing almost black in reduction.

Terracotta An iron-bearing earthenware clay that matures at low temperatures and fires to a rich red colour.

Thermal Shock A sudden increase or decrease in temperature that puts great stress on a fired clay body, causing it to crack.

Thermocouple An instrument placed in a kiln to measure the temperature.

Thixotropy A property of casting slips which become more fluid when agitated.

Torsion Viscometer A device used to measure the fluidity and thixotropy of liquids.

Turning or Trimming Removing spare clay from the base of a thrown pot with a sharp loop tool while the pot revolves on the wheel.

Twaddell (TW) A measure for the specific gravity of solutions and suspensions, i.e. sodium silicate.

Underglaze A colour that is usually applied to either greenware or bisque-fired pottery and in most cases covered with a glaze.

Vitrified A term that refers to clays which fire to high temperatures so that the clay particles fuse together and the object becomes glass-like.

Wax Resist The process of decorating by painting wax on a surface to resist a water-based covering.

Wedging A method of preparing clay for use or mixing different clays together to produce an even, air-free consistency.

Additional references

Alumina [Al_2O_3] Increases glaze viscosity, firing range and resistance to crystallisation.

Alumina Hydrate [$Al(OH)_3$] An alumina source rarely used in clay bodies or glazes but for kiln shelf wash, wadding, and in a granular form, as a placing sand for firing delicate items and bone china. Small additions increase the viscosity of glaze melt but should not be used as a matting agent because it produces immature glaze; it is not suitable for functional glazing.

Barium Carbonate (Poisonous) A secondary flux in stoneware and porcelain glazes that produces vellum matt. Up to 2.5 per cent can be added to some clay bodies to prevent scumming arising from soluble salts.

Borax (Poisonous) A vigorous low-temperature glaze flux. Slightly soluble in water so usually introduced to glazes as a frit.

Calcium Chloride A compound used as a flocculent in glazes, having the effect of allowing the glaze constituents to settle in a loosely packed arrangement and thus making them more easily reconstituted.

Mix the flocculent in a cup with hot water until no more can be dissolved. Allow to cool and then mix only a few drops per litre of glaze and mix thoroughly. Larger additions will cause the glaze to thicken, which is useful when applying the glaze to vitreous wares.

Christobalite (Hazardous if inhaled) A powdered, prefired form of silica used to improve craze resistance of slips and bodies.

Colemenite (Boro–Calcite) A useful and powerful flux used in glazes to introduce an insoluble form of boron with calcium.

Dolomite A naturally occurring combination of calcium and magnesium carbonates providing a secondary flux for high-temperature porcelain and stoneware glazes.

Feldspar A common and naturally occurring mineral used as the major flux in clay bodies and in high-temperature glazes.
 Potash feldspar (orthoclase) The most commonly used form of feldspar.
 Soda feldspar (albite) Another form of feldspar.

Fireclay Refractory clay used as an additive to stoneware bodies to produce an open texture and speckling (under reduction).

Flint (Hazardous if inhaled) A refractory material used to provide silica in bodies and glazes. It increases firing temperature and craze resistance but reduces plasticity and shrinkage.

Gerstley Borate [$2CaO, 3B_2O_3, 5H_2O$] A variety of Colemenite; it is used as a flux in studio glazes.

Lithium Carbonate An alkaline flux used as a substitute for potash or soda where a good craze resistance is required. It provides an alkaline colour response.

Magnesium Sulphate (Epsom salts) A compound used to flocculate glazes to assist suspension and application to more vitreous wares. See also *calcium chloride*.

Nepheline Syenite A mineral mixture of feldspar and hornblende with a little silica. More fusible than feldspar, it can be used as a replacement to reduce the maturing range of glazes and bodies.

Quartz (Hazardous if inhaled) A form of silica used as an alternative to flint in glazes but not an exact alternative to flint in clay bodies.

Rutile An ore containing titanium dioxide with iron oxide used to produce a mottled buff brown colour (3–8 per cent) especially in the presence of ilmenite. It increases the opacity of glaze, so exciting effects can be achieved in combination with stains or colouring oxides.

Silica Sand (Usually available in several grades) Sand used as a grog for clay bodies or as a placing sand for firing.

Talc Also known as French chalk/magnesium silicate/soapstone. A secondary flux introducing magnesium and used to improve craze resistance in glazes. Also a flux for clay bodies.

Tin Oxide The oldest and most widely used opacifier producing a soft white. Add 5–10 per cent for opacity.

Whiting (Chalk/Limestone) Calcium Carbonate. The main source of calcium in glazes and extensively used as a flux in stoneware and porcelain glazes. It assists hardness and durability and in large quantities produces a matte finish.

Wollastonite (Calcium Silicate) An alternative to whiting as a source of lime in stoneware glazes. Useful where pin-holing is a problem.

Zircon (Zirconium Silicate) An ultra fine form of zircon used as an opacifier. Add 5–8 per cent for semi-opaque and 10–15 per cent for fully opaque glazes.

Index